naturescapes

NORTH LIGHT BOOKS
CINCINNATI, OHIO
www.artistsnetwork.com

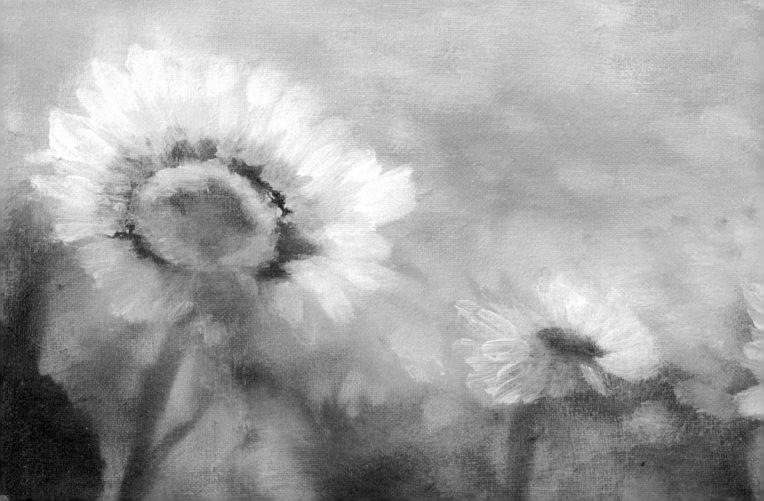

nature
scapes

innovative painting techniques
using acrylics, sponges, natural materials & more

terrence lun tse

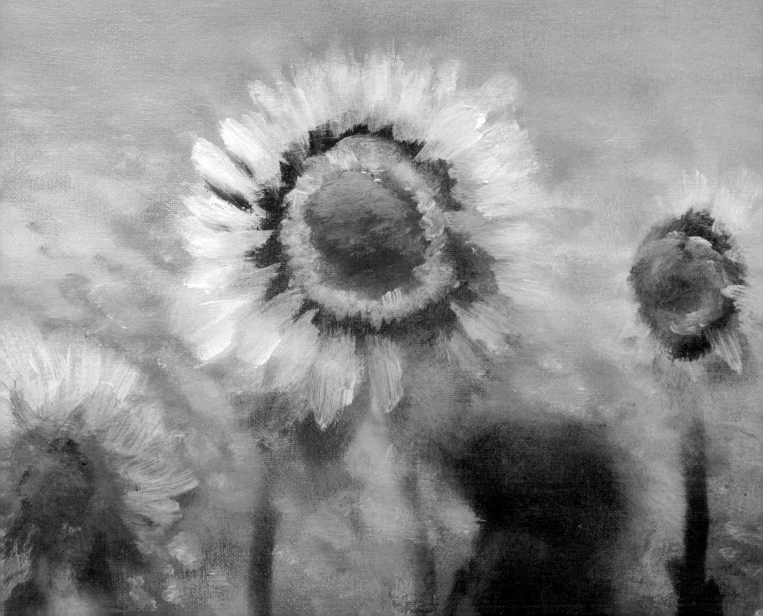

naturescapes. Copyright © 2010 by Terrence Lun Tse. Manufactured in China. All rights reserved. No part of this book may be reproduced in any form or by any electronic or mechanical means including information storage and retrieval systems without permission in writing from the publisher, except by a reviewer who may quote brief passages in a review. Published by North Light Books, an imprint of F+W Media, Inc., 4700 East Galbraith Road, Cincinnati, Ohio 45236. (800) 289-0963. First Edition.

edited by jennifer lepore brune

designed by jennifer hoffman

production edited by mona michael

production coordinated by mark griffin

Other fine North Light Books are available from your favorite bookstore, art supply store or online supplier. Visit our website at **www.fwmedia.com**.

14 13 12 11 10 5 4 3 2 1

ART ON FRONT COVER:

wild pastels
acrylic and spray paint on 24" × 18" (61cm × 46cm) gessoed canvas

ART ON TITLE PAGE:

sea of sunshine
acrylic and spray paint on 18" × 24" (46cm × 61cm) gessoed canvas

DISTRIBUTED IN CANADA BY FRASER DIRECT
100 Armstrong Avenue
Georgetown, ON, Canada L7G 5S4
Tel: (905) 877-4411

DISTRIBUTED IN THE U.K. AND EUROPE BY DAVID & CHARLES
Brunel House, Newton Abbot, Devon, TQ12 4PU, England
Tel: (+44) 1626 323200, Fax: (+44) 1626 323319
Email: postmaster@davidandcharles.co.uk

DISTRIBUTED IN AUSTRALIA BY CAPRICORN LINK
P.O. Box 704, S. Windsor NSW, 2756 Australia
Tel: (02) 4577-3555

metric conversion chart

TO CONVERT	TO	MULTIPLY BY
Inches	Centimeters	2.54
Centimeters	Inches	0.4
Feet	Centimeters	30.5
Centimeters	Feet	0.03
Yards	Meters	0.9
Meters	Yards	1.1

Library of Congress Cataloging in Publication Data
Tse, Terrence, 1964-
Naturescapes / Terrence Lun Tse. -- 1st ed.
p. cm.
Includes bibliographical references and index.
ISBN 978-1-60061-794-2 (pbk. : alk. paper)
1. Nature (Aesthetics) 2. Painting--Technique. I. Title.
ND1460.N38T79 2010
751.4'26--dc22 2009037832

About the Author

Terrence Lun Tse is a Master Artist and Lead Designer with Deljou Art Group (Atlanta, Georgia), the world's leading publisher, producer and distributor of fine art prints. His original designs and prints are exhibited and sold at major art expos, fine art galleries and home decorating chain stores throughout the world.

Terrence has been a featured artist in two North Light *Painter's Quick Reference* books: *Trees & Foliage* and *Landscapes*. He is the author of two North Light books: *Painting Murals Fast & Easy* and *Sponge Painting*.

Acknowledgments

Many thanks to Kathy Kipp, Jennifer Lepore and Christine Polomsky. Special thanks to Daniel Deljou.

for Sunlun, Stephanie & Chuii

table of contents

summer

autumn

winter

spring

introdu

Artists are known for their love of Nature and for portraying it in their work. Whether represented as tiny close-ups of rocks, leaves and butterfly wings, or grand vistas of mountains, trees, lakes and skies, nature has a special place in the hearts of artists, and in the viewers who see their art.

You, too, must be a nature lover as you have picked up this book and are ready to learn how to portray your own naturescapes. My view of nature ranges from intimate garden scenes to romantic pathways through waving grasses, and with the demonstrations in this book, I'll teach you how to capture these beautiful scenes.

With *Naturescapes* you will be introduced to a unique way of painting nature and landscapes using (what better?) materials from Nature herself, as well as other found objects, spray paint, acrylic paint, and ordinary household sponges. The techniques throughout this book will provide you with fast and easy methods for creating beautiful paintings, whether you paint the scenes from the book, or your own natural spaces.

I hope the lessons you learn here spark a new direction in your art and give you inspiration to try these new techniques with other subjects for many paintings to come.

thistling in the wind
acrylic and spray paint on 24" × 24" (61cm × 61cm) gessoed canvas

9

materials & techniques

our moment
acrylic and spray paint on 24" × 24" (61cm × 61cm) gessoed canvas

1

basic materials

These are the basic materials used to create the paintings in this book. They can be purchased at your local home improvement center, grocery or art and craft supply store.

Acrylic Paints

Acrylic waterbased paints can be found at art and craft supply stores and come in a variety of colors. For the paintings in this book I used three brands. Liquitex Artist Acrylic Color (high viscosity/heavy body) and Golden Artist Colors (heavy body) come in tubes. Utrecht Artists' Paint Series 1 Acrylic (high viscosity) comes in one-pint (16 fluid ounce) jars. All are perfect for applying with a sponge because they are thicker bodied than bottled craft acrylics—a little dollop on your palette goes a long way.

Spray Paint

Spray paint is available at any art and craft supply store or home center and comes in a variety of colors. For the paintings in this book I used Krylon Indoor/Outdoor Flat White Enamel, but any type will do, as long as it isn't gloss enamel. Gloss enamel will not allow subsequent layers of acrylic paint to be layered on top, making the technique we use in this book ineffective.

Water Bucket

You'll want a small one- or two-gallon (4–8 liter) bucket of water to rinse your sponges in as you paint. Place an old towel underneath to catch drips.

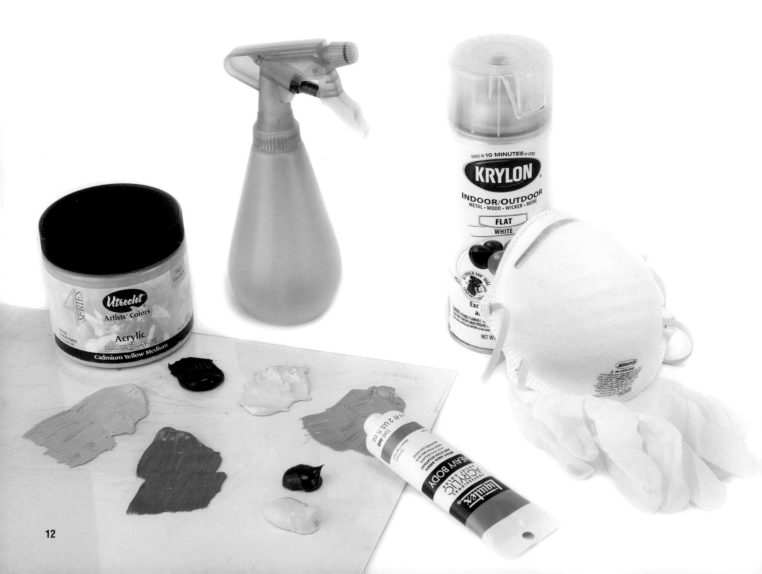

Spray Bottle of Water

Use this to mist the canvas as you paint, to keep your paint wet on your sponge or palette, and to thin the paint on your palette if needed.

Safety Supplies

When working with spray paint or acrylics you will come into contact with paint and paint fumes. You can use a disposable face mask and thin, disposable rubber gloves to avoid inhaling or touching the paint.

Palette

A piece of Plexiglas works well as a palette for your paints. When you're finished painting your project, just wipe off the excess paint with a damp sponge.

Painting Surfaces

All of the paintings in this book were done on either 24" × 24" (61cm × 61cm) or 18" x 24" (46cm × 61cm) pre-stretched, pre-gessoed canvases or 18" × 24" (46cm × 61cm) 140-lb. (300gsm) watercolor paper available at any art supply store. Either one will work for the techniques used in this book. If you use watercolor paper, you must coat it with gesso and allow it to dry prior to painting. For a more inexpensive option, buy rolls of unstretched canvas at an art and craft supply store and cut them 2 inches (5cm) larger than your final painting surface on each side. Then staple them to wooden stretcher bars, also available at any art and craft supply store, and apply a coat of gesso.

Painter's or Masking Tape

To create a crisp edge around your paintings you will want to apply a strip of painter's or masking tape along the edge of the canvas or paper. Once you are finished painting, you can remove the tape for an even border around your painting.

Household Cleaning Sponges

These are the sponges you see in most stores that sell cleaning products. These ordinary sponges come in different colors and sizes. They are cellular composite with breadlike pores and texture. It is more economical for you to purchase the large ones (7½" × 4" × 2"/19cm × 10cm × 5cm) and cut them into smaller, easier-to-handle sizes with scissors.

Scissors or Utility Knife and a Ruler

Use scissors or a utility knife and a ruler to cut your sponge into manageable pieces.

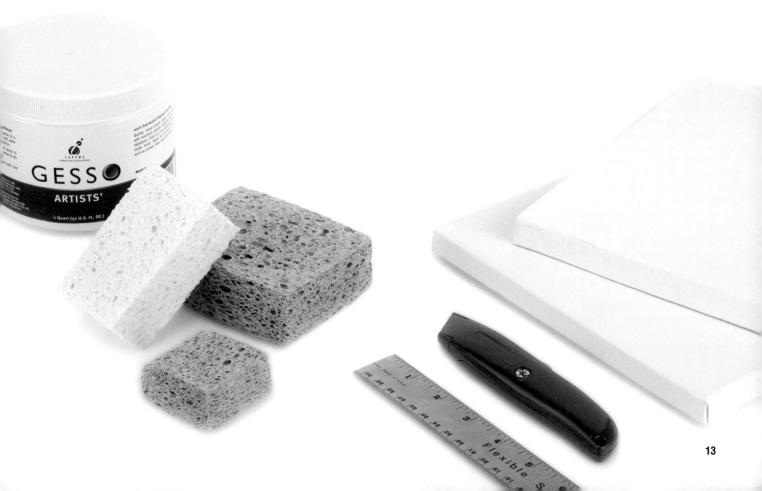

specialty materials

The unique spray painting technique used in this book requires natural and man-made materials to create the compositions. You'll want to have a sampling of these materials handy when completing the painting demonstrations. These materials can be found in your local home improvement center, art and craft supply store, or outside in your own backyard.

NATURAL MATERIALS

Your own backyard is a good place to find these small branches and twigs from trees and bushes, both with and without leaves. Various types of foliage, grasses, pinecones and small flowers will also come in handy. You'll want to have some shells on hand as well. (You can find these for sale at your local art and craft supply store.)

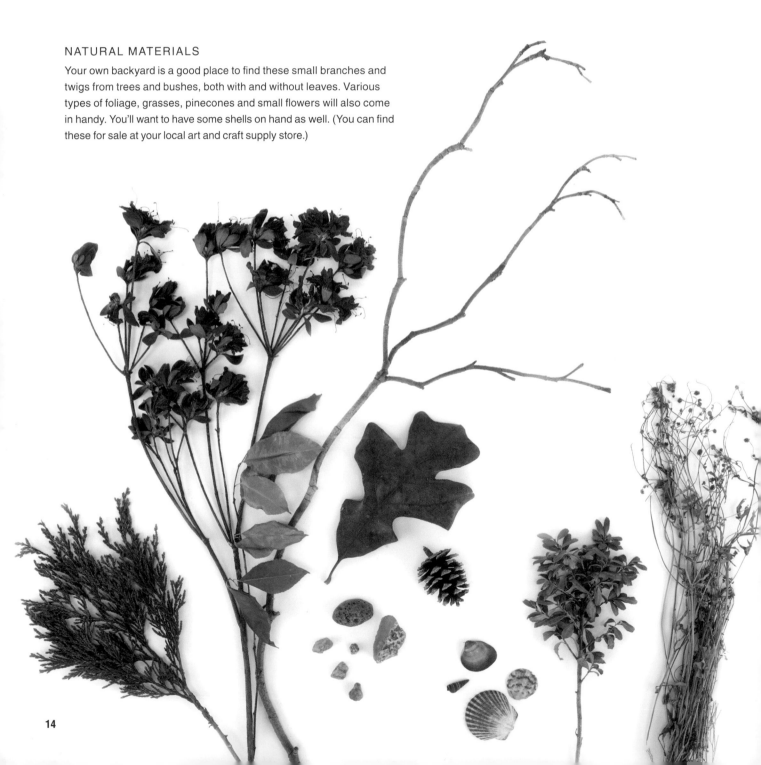

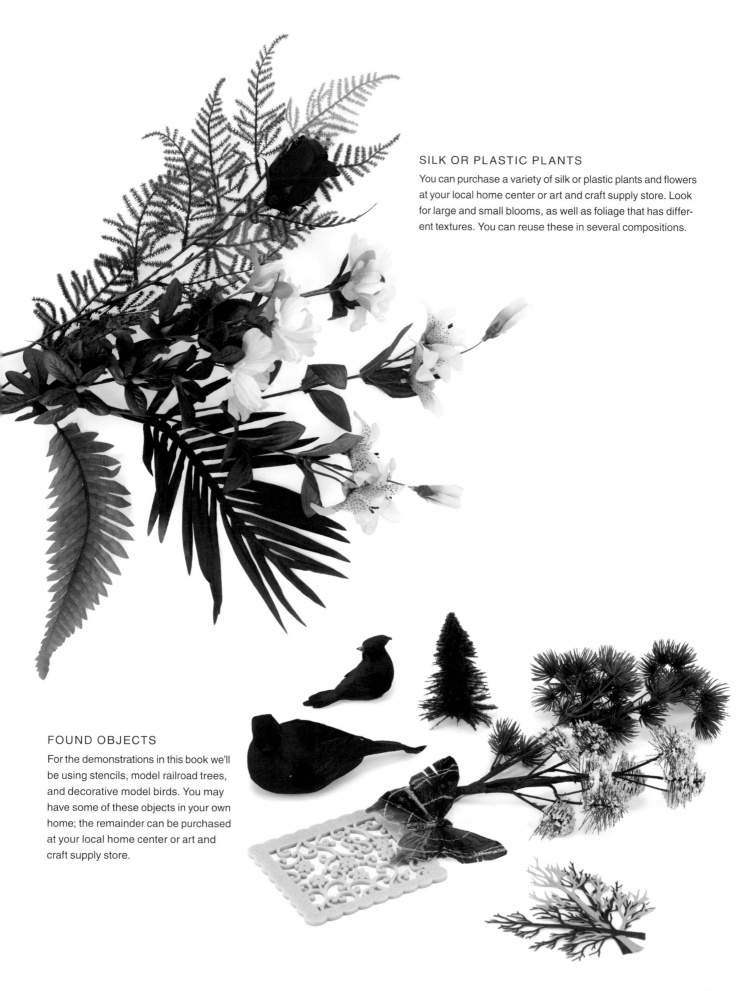

SILK OR PLASTIC PLANTS

You can purchase a variety of silk or plastic plants and flowers at your local home center or art and craft supply store. Look for large and small blooms, as well as foliage that has different textures. You can reuse these in several compositions.

FOUND OBJECTS

For the demonstrations in this book we'll be using stencils, model railroad trees, and decorative model birds. You may have some of these objects in your own home; the remainder can be purchased at your local home center or art and craft supply store.

cutting the sponge

In this book you will be painting with acrylics using common household sponges instead of brushes. Painting with sponges is fun and fast, allowing for quick cleanup (and a little extra money in your pocket since sponges are so inexpensive compared to brushes).

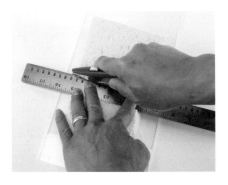

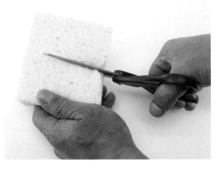

SPONGE SIZES

For the demonstrations in this book we'll use three sizes:

Small: 2¨ × 2¨ (5cm × 5cm)

Medium: 2¨ × 4¨ (5cm × 10cm)
this is the main size you will use

Large: 3¼¨ × 4¨ (8cm × 10cm) (half a block)
you will use this for large washes

CUT THE SPONGE WITH A UTILITY KNIFE AND RULER

Place the large sponge on a surface you can cut into (a cutting board or small piece of Plexiglas). Press down on the sponge with your ruler and cut through the sponge with your utility knife.

CUT THE SPONGE WITH SCISSORS

You can also cut the sponge using a sturdy set of scissors. Once your sponge is cut to size, trim off any stray pieces so you get a nice flat surface on all sides of the sponge.

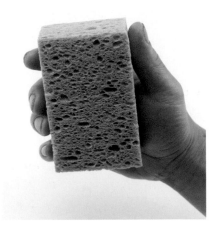

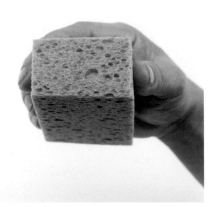

THE FLAT SIDE (LEFT)

In the painting demonstrations in this book, you will see instructions about loading or painting with the flat side of your sponge. This is the largest area on the sponge.

THE TOP EDGE (RIGHT)

This sharp edge separates the flat side and the top side of the sponge. You will be using the top edge often to make thin, brushlike lines and crisp edges in your paintings.

holding the sponge

The three different sponge sizes we created are almost like three different brush sizes. For even more control as you paint, you can alter the way you hold the sponge depending on whether you want to paint large washes or small details.

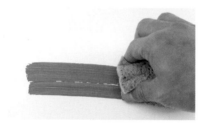

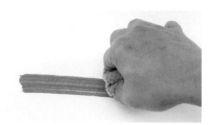

NO PINCH
Hold the sponge without any squeeze or pinch when you want to lay a wash of paint, or for applying long sweeps of paint. This is how you will hold the sponge when you apply background washes.

GENTLE PINCH
If you squeeze the sides just slightly to reduce the width of the sponge's painting area, you'll be able to apply a thinner stroke. You'll use this hold for more precise shapes.

TIGHT PINCH
When you squeeze the sides of the sponge tightly between your thumb and first two fingers you will create an even smaller surface to paint with and a thinner stroke. Use this type of pinch to paint small details such as flower petals and leaves, or any time you need the greatest control.

Using Both Sides of the Sponge

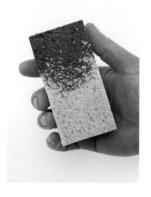

1| THE SIDE WITH PAINT

2| THE FLIP SIDE
Use your thumb and index finger to flip the bottom of the sponge upward.

3| THE CLEAN SIDE
Now you have the clean side of the sponge ready to wipe off paint, blend or soften color, or clean up an edge.

painting with the sponge

There are many different ways to load your sponge with paint, and each one will help you create a different effect in your paintings.

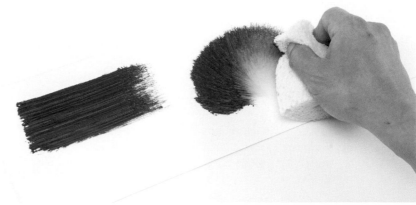

TOP HALF LOAD

This will be the main way you will load your sponge for the demonstrations in this book. You'll use this type of load for straight, flat application of paint. If you pinch the sponge with this load, you can create rounded edges when you apply the paint with a circular stroke.

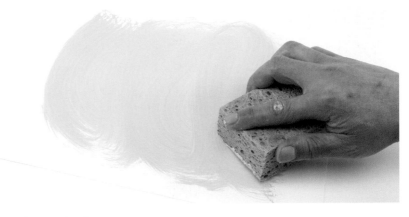

FLAT SIDE LOAD

To paint large areas quickly, load the entire face of the sponge by pressing the sponge into a large puddle of paint.

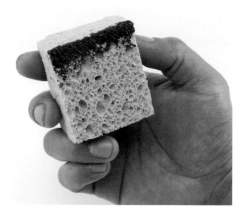
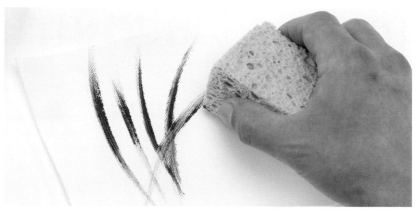

TOP EDGE LOAD

Carefully load just the very top edge of your sponge to paint hard edges and elements such as grasses and twigs.

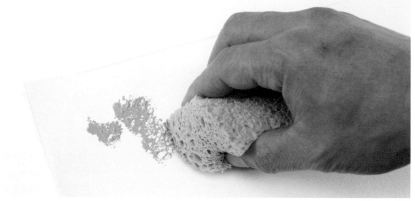

CORNER LOAD

Load just the corner of your sponge for more control painting small areas and to make brushlike strokes, as well as to dab in color.

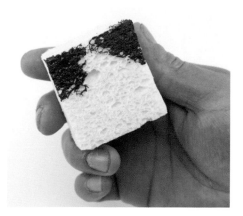
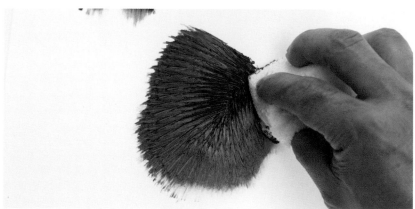

DOUBLE CORNER LOAD

You can also load your sponge with two different colors, one on each upper corner. With this type of load you can apply each color separately or apply both at once by pinching the sponge, blending the colors together as you apply the paint. This type of load is good for laying in flowers and grass—you can highlight with just one stroke of the sponge.

more sponge strokes

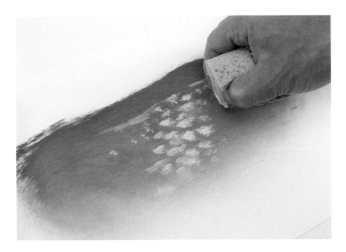

DABBING

A tight pinch with the corner or top half sponge load is a great way to paint reflections on water or sky spots between your trees.

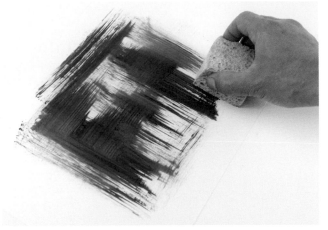

CROSSHATCHING

Load the top half of the sponge and stroke the sponge flatly down and across the surface without pinching it. This creates a great textural effect for backgrounds.

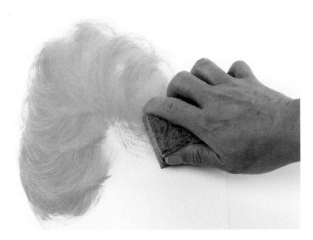

CIRCULAR STROKES

Load the entire flat side of the sponge with color and apply it without pinching in a circular motion across the surface. This works well for laying on large background washes of color and to help blend paint.

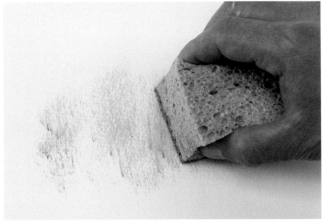

DRY SPONGING

Squeeze all the water out of your sponge and apply a little paint to the sponge. Paint lightly over the surface to pick up the paper texture. (You can also use your sponge as a stamp, stamping on the texture of the sponge itself.)

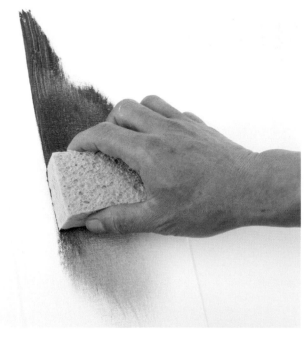

BLENDING WITH YOUR SPONGE

If you are painting and want to blend or fade the color you just applied, you can just flip your sponge to the clean side!

keep the sponge moist

If your paint needs to be thinned to create a large wash, or the sponge just feels like it's dragging across the surface, spritz it lightly with clear water from a spray bottle to keep it workable.

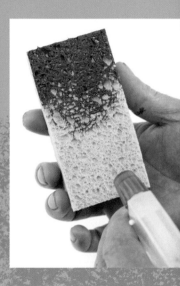

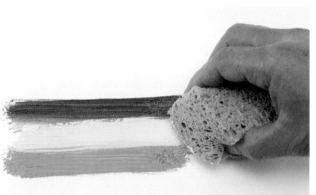

BLENDING WITH UNBLEACHED TITANIUM

If you apply Unbleached Titanium between two separate colors, you can blend and fade the two into each other quickly.

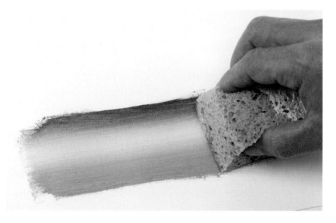

APPLY A FAST HORIZON LINE

Put in a heavy stroke of paint horizontally, then use the back of the sponge and a vertical stroke to fade out color up and down, creating what looks like ridges and grasses in the distance.

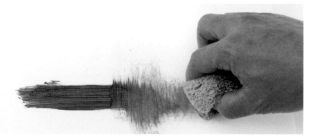

other nifty techniques using sponges

Sponges are just as capable as brushes for creating delicate washes and small details in your paintings. Experiment on your own to see what other effects and techniques can be achieved with your sponge.

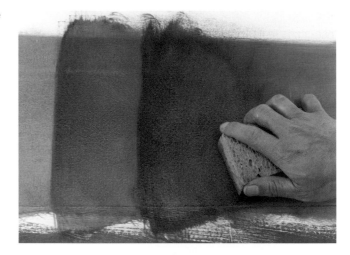

GLAZING

Layering your paint will create beautiful glowing colors, with each new layer enriching the color. For this effect to work it is important to let the paint dry between each layer.

LIFTING

If you need to recover your underpainting or go back to the white of the paper, use a moist clean sponge to lift out the colors.

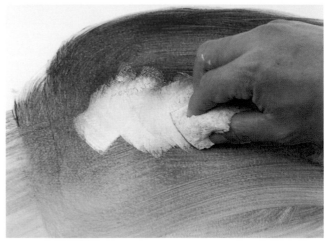

USING YOUR SPONGE AS A PORTABLE PALETTE

If you will be using a color for awhile, you don't have to keep going back to your palette for more paint—just use another sponge as a portable palette. Wet this sponge slightly and pick up a large dollop of paint on the larger, flat side for an instant palette.

using spray paint

In this book you will use natural and man-made materials in conjunction with spray paint to create compositions. This may sound like a strange combination, but this unique technique is a quick and easy way to get your paintings started.

The idea behind this technique is to use your natural or man-made materials as stencils. Once you've arranged your composition on the painting surface with the materials, you'll spray them with paint, leaving behind the outline of the materials—and a negative image of your composition.

spray painting tips

- *Wear rubber gloves and a mask to keep the spray from entering your lungs or getting on your hands.*
- *The more you press down on the object, the sharper the image will be.*
- *Spray in short bursts.*
- *Spray as straight down as you can (perpendicular to the paper).*
- *Any spray paint will work, except high gloss enamel. (Flat paint works very well.)*
- *It's OK to use color or white spray paint (we use white only in this book).*
- *You can spray vertically (on an easel) in small doses.*

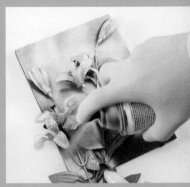
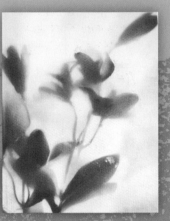

1| BASE LAYER OF COLOR
Paint your base layer of color and let it dry. This color base will be the first layer of your scene's background. Here the background is a cool blue, and will suggest a cold winter sky.

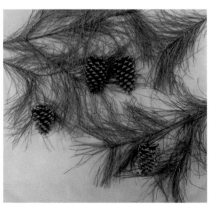

2| ARRANGE THE COMPOSITION
Play with the placement of your materials on the painting surface to create a pleasing composition. Here I wanted to paint a close-up of a pine bough so I arranged natural pine branches and pinecones on the painting's surface.

3| SPRAY THE MATERIALS
Once your composition is in place, hold the materials down with one hand and spray paint directly onto the materials, keeping the can of spray paint parallel with the painting surface about 4 to 6 inches (10 to 15cm) from the materials, and spraying in short bursts. The more you press down on the materials as you spray, the sharper the image will be.

painting
demonstrations

first light
acrylic and spray paint on 24" × 24" (61cm × 61cm) gessoed canvas

2

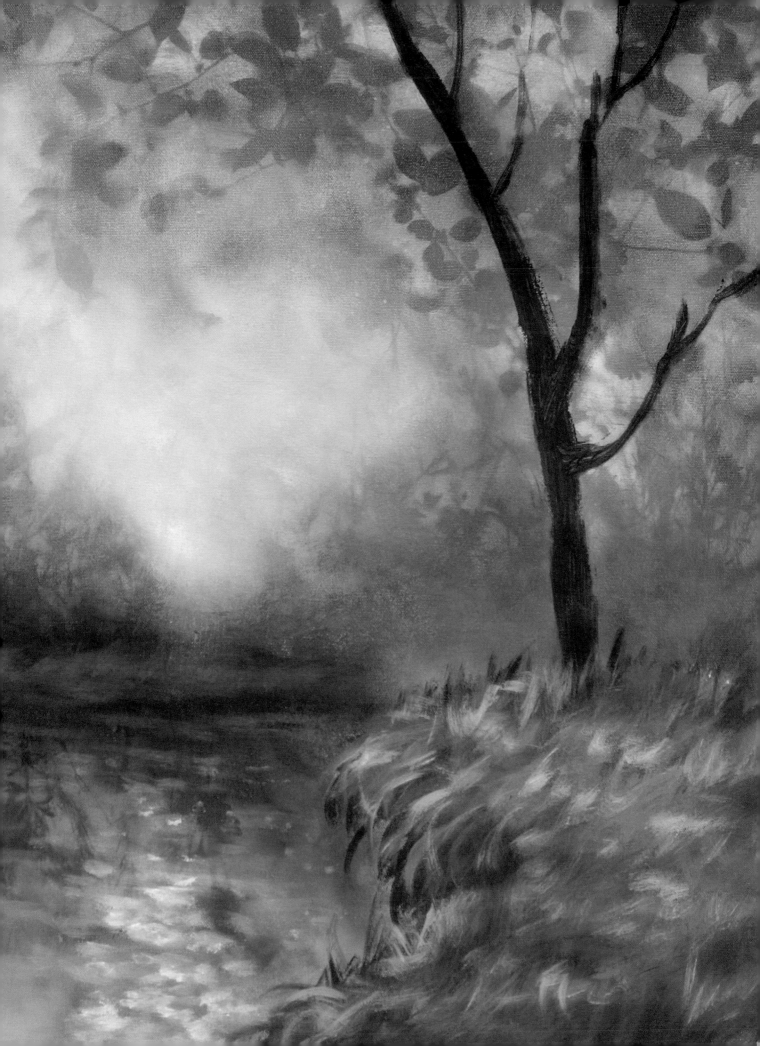

leaves above

Sun filtering through the wind-stirred leaves of a shade tree is a welcome and restful sight on a hot summer day. To paint this glowing, filtered play of light, greens and yellows provide a warm basecoat for the leaves, with a cool blue showing through here and there to portray glimpses of the blue sky above.

materials

NATURAL PLANTS
ficus leaves and branches

SURFACE
140-lb. (300gsm), 24" × 18" (61cm × 46cm) gessoed watercolor paper

Cadmium Yellow Medium

Light Blue Violet

Raw Sienna

Raw Umber

Sap Green

Titanium White

Unbleached Titanium

Light Yellow Green (Sap Green + Cadmium Yellow Medium)

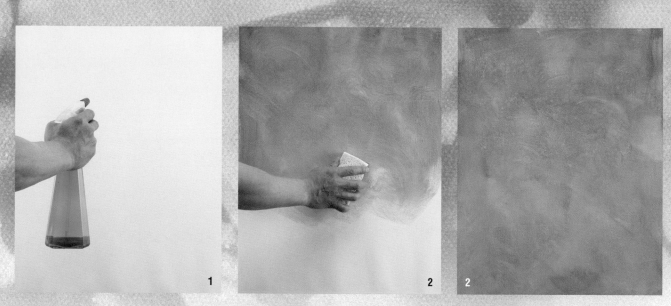

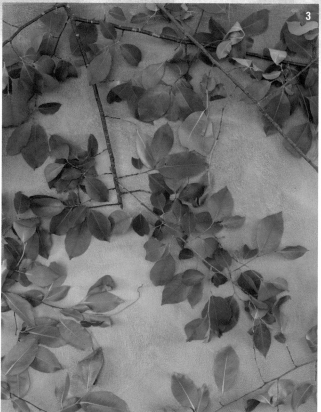

1| PREPARE YOUR SURFACE FOR PAINT

When you are ready to start painting, use a spray bottle and clear water to lightly mist the surface.

2| APPLY THE BASECOAT

Use the flat side of your large sponge to paint in the background with a thin wash of Sap Green, using circular strokes and a gentle squeeze. Let dry.

3| COMPOSE AND PLACE YOUR PROPS

Compose an arrangement of ficus tree branches on the background, keeping in mind that you will be painting a view of a tree as you look up through the leaves to the sky above.

4| SPRAY THE DESIGN

As you spray, hold down any sections of branches that are rising too high from the surface so you get a good impression of the leaves.

5| DEVELOP THE DARKS

Load a medium sponge with Raw Umber to place some darks in the sky area first. Use circular strokes and apply right over the leaves in some areas. Blend in the color.

Then add Sap Green with a medium sponge to darken areas of the foliage.

6| DEVELOP WARMTH

Apply Raw Sienna with your medium sponge to add warm spots. When you wash color over the underlayers, the colors change and become varied. Blend in.

Make a Light Yellow Green with Sap Green and Cadmium Yellow Medium, then use your medium sponge to apply this color here and there as warm sun glowing through the leaves.

7| DEVELOP THE SKY

Apply Light Blue Violet as sky spots with your small sponge. The areas you are adding paint to are becoming smaller, hence the small sponge.

Apply Unbleached Titanium with a small sponge and build light areas. Dab on color to control where you place it, blending the white into the painting.

8| BRIGHTEN UP YOUR LIGHTS

Use your small sponge to apply Titanium White over the Unbleached Titanium to strengthen the sunlight effect, dabbing on color to control placement then blending into the painting.

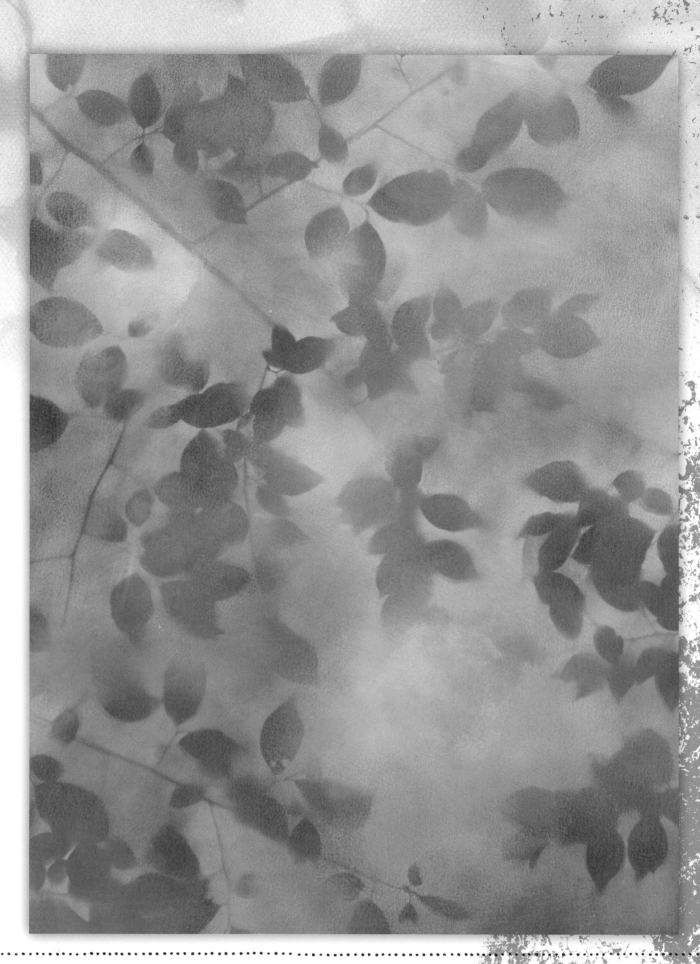

leaves above | acrylic and spray paint on 24" × 18" (61cm × 46cm) 140-lb. (300gsm) gessoed watercolor paper

rose glow

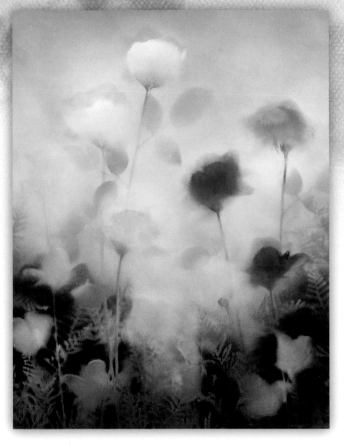

Brilliant blooms brighten up the garden and the canvas! Add spots of color to the areas where the rose heads will be placed before you spray the composition in place. This will ensure that the blooms stay bright and rich, glowing in the summer sun.

Brilliant Yellow Green

Burnt Sienna

Cadmium Orange

Cadmium Red Light

Cadmium Red Medium

Cadmium Yellow Medium

Raw Sienna

Sap Green

Titanium White

Unbleached Titanium

Dusty Rose (Cadmium Red Medium + Unbleached Titanium)

Light Brown (Raw Sienna + Unbleached Titanium)

materials

SILK PLANTS
ferns
roses

SURFACE
24" × 18" (61cm × 46cm) gessoed canvas

1| PREPARE THE SURFACE AND APPLY THE BLOOM BASE COLORS

Lay out your paints on the palette and mist them lightly. Apply the background colors of the rose heads with your small sponge in circular strokes using Unbleached Titanium, Cadmium Red Medium, Dusty Rose, Cadmium Yellow Medium and Brilliant Yellow Green. Paint this into a triangular arrangement of blooms so the viewer's eye will travel around the painting.

2| APPLY THE BACKGROUND BASECOAT

Use your small square sponge to add Sap Green around the rose heads, squeezing it tightly to get between the small spaces. Let this dry.

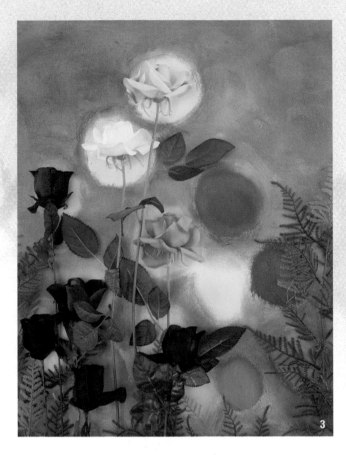

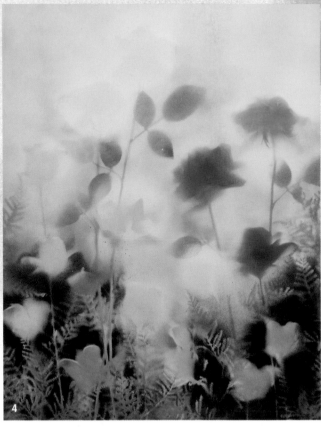

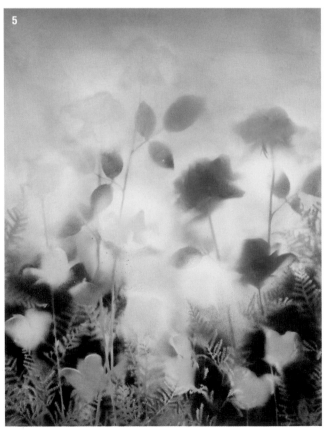

3| COMPOSE AND PLACE YOUR PROPS

Compose silk roses and ferns on the background. Place the rose heads over the background colors you painted. Use the ferns as greenery at the bottom of the painting.

4| SPRAY THE DESIGN

As you spray, hold down any objects that are rising too high from the surface so you get a good impression of the leaves and blooms. If you don't have enough props, just spray those you do have, move them to a new place and spray again.

5| WARM THE SKY

Wash Light Brown with a medium sponge over the top of the painting using a circular motion. Keep the wash heavy at the top and fade down. It's OK to wash right over the rose heads.

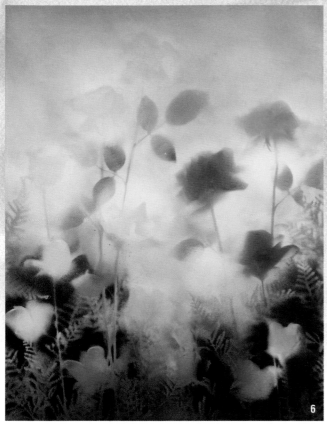

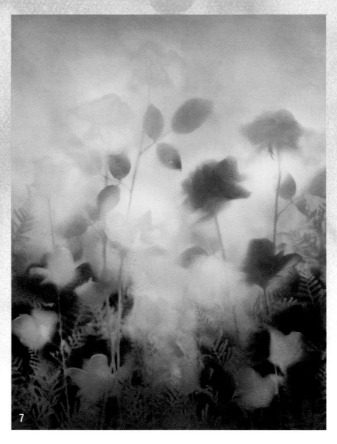

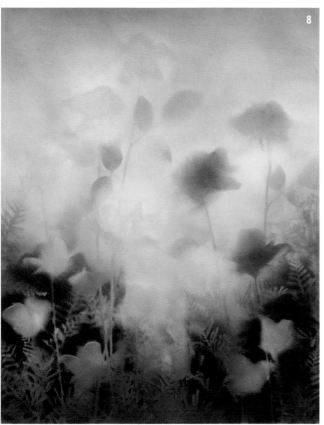

6| WARM THE FOLIAGE

Apply Burnt Sienna at the bottom of the foliage area with a medium sponge using circular strokes and fading up as you go. It's OK to paint right over the roses and foliage. Blend the color into the painting.

7| DARKEN THE FOLIAGE

Still using the medium sponge, wash on Sap Green from the bottom up on both sides of the painting.

8| BLEND THE FOLIAGE COLORS

Use your medium sponge to wash Unbleached Titanium over the middle area of the painting to blend the green and sienna colors you applied in steps 6 and 7. Work around the roses to keep the central part clear of the white so you retain the vibrancy of color. The more you wash white over the leaves, the more you push them into the background.

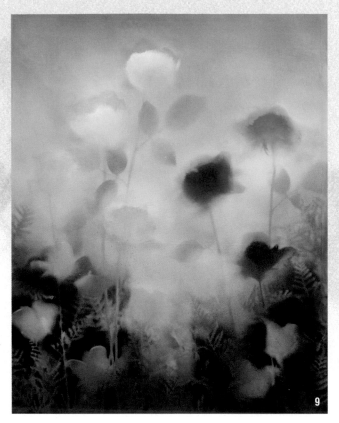

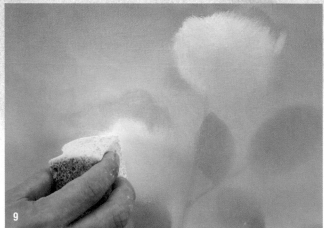

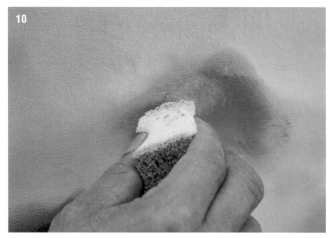

9| STRENGTHEN THE COLORS OF THE ROSES

With your small sponge, add more color and detail to some of the rose blooms using the colors you used for each rose in step 1. Load the color in the corner of the sponge and use the sponge edge to get a sharp edge at the top, then fade down the bloom, creating petal shapes. Don't push the roses so far that they become soft and lose the nice sharp shapes created when you sprayed them in place.

10| ACCENT THE ROSES

Add highlights to some of the roses. Use Cadmium Yellow Medium on the orange rose, pinching the sponge tightly and drawing the color down the bloom. Do the same with the red roses using Cadmium Orange and Cadmium Red Light.

For the white roses apply Sap Green at the base of the blooms, fading the color up the petals. Pinch the sponge and use the corner to work the paint up.

Add this green base to the orange, red, yellow and green roses, using the same technique as you did for the white rose. Strengthen the rose stems with Sap Green using the corner of the sponge.

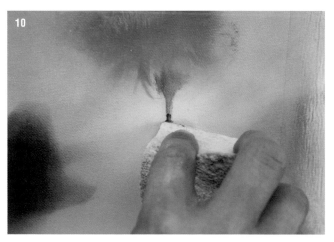

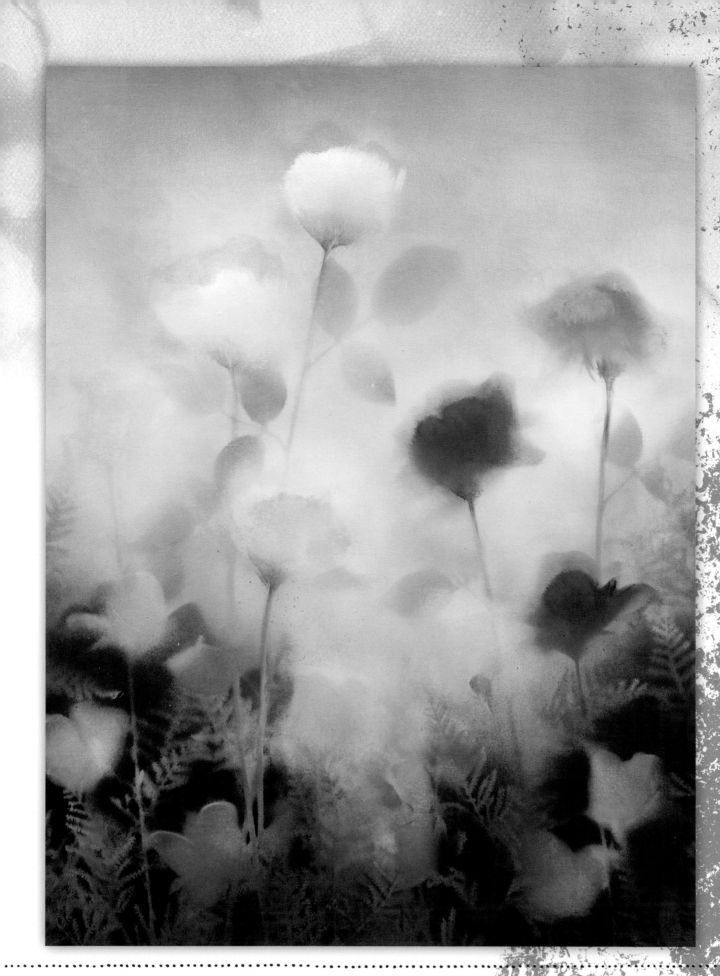

rose glow | acrylic and spray paint on 24" × 18" (61cm × 46cm) gessoed canvas

tigers at bay

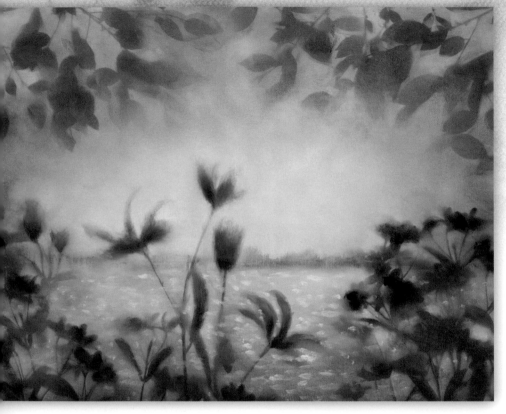

Create the mood of a secret tropical hideaway by establishing overhanging trees, a flowery foreground, distant landmass and sparkling waters.

materials

NATURAL PLANTS
ficus leaves and branches

SILK PLANTS
tiger lilies
smaller flowers with foliage

SURFACE
18" × 24" (46cm × 61cm)
gessoed canvas

Brilliant Purple

Burnt Sienna

Burnt Umber

Cadmium Orange

Cadmium Red Light

Cadmium Red Medium

Cadmium Yellow Medium

Dioxazine Purple

Light Blue Violet

Raw Sienna

Raw Umber

Sap Green

Titanium White

Ultramarine Blue

Unbleached Titanium

*Light Yellow Green
(Sap Green + Cadmium
Yellow Medium)*

1| PREPARE THE SURFACE AND APPLY THE BLOOM BASE COLORS

Lay out your paints on the palette and mist them lightly. Use your medium sponge to apply Cadmium Orange for the lily background and Dioxazine Purple for the purple flowers, using circular strokes and a gentle squeeze.

2| APPLY THE BACKGROUND BASECOAT

Use your large sponge with a gentle squeeze to apply Sap Green to the foliage background, working the color into the other colors at the edges. A nice blend between colors creates a full background. Let this dry.

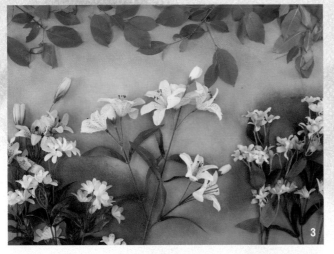

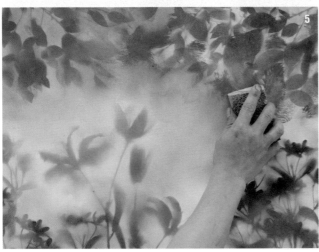

3| COMPOSE AND PLACE YOUR PROPS

Compose ficus tree branches, silk tiger lilies and silk blue and purple flowers on the background. The tree branches will be an overhanging bough across the top, and the flowers will be scattered across the lower half as a foreground screen through which you can see the bay and distant landmass.

4| SPRAY THE DESIGN

As you spray, hold down any objects that are rising too high from the surface so you get a good impression of the leaves and blooms.

5| WARM THE OVERHANGING TREE AREA

Fill in the spaces between the leaves at the top of the painting with Raw Sienna and your medium sponge, blotting in color first then blending it into the painting.

6| STRENGTHEN FOLIAGE AT THE TOP AND BOTTOM

Add Sap Green to the top and bottom of the painting in the foliage areas. Start at the bottom first to allow the previous sienna layer on top to dry. Strengthen any greens that got lost with the spray paint. Use a lighter wash of the Sap Green at the top. After washing on color, come back in with a clean sponge and wipe out color here and there to create negative shapes of sunlight coming through the trees.

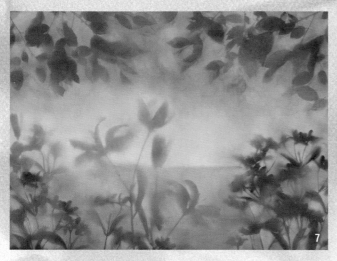

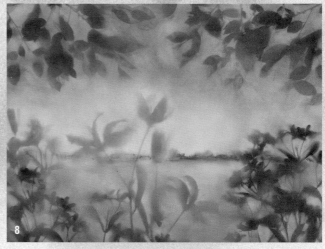

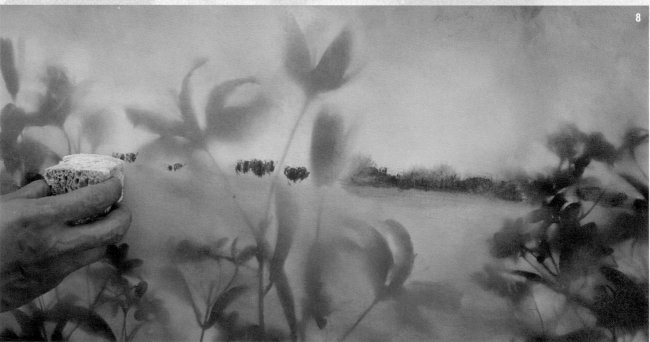

7| PAINT IN THE WATER

Using Light Blue Violet and your medium sponge, establish a horizon line with the edge of sponge fairly heavy at first, then fade the color down. Dab in color between the plants at the bottom, flipping the sponge to blend the blue into the foliage. It's OK to paint over the plants with the blue. If you paint over too much and you want a color to come back (say you lose an orange), go in with a clean sponge and lift the blue from that area.

8| ADD A DISTANT LANDMASS

To establish some distant land, double load a small sponge with Burnt Umber and Raw Sienna, and bounce the sponge from corner to corner along the horizon. Use horizontal strokes to blend the color together somewhat.

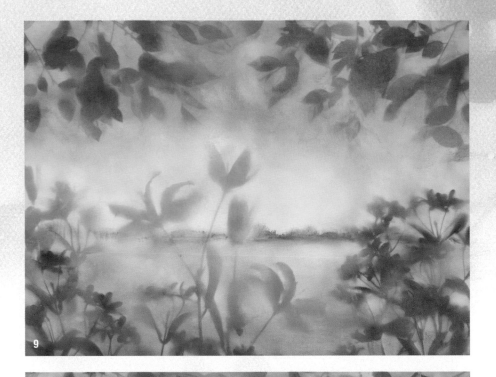

9| STRENGTHEN THE WATER

Use Ultramarine Blue and work from the bottom up to strengthen the water with your small sponge. Dab in color and blend.

10| INCREASE THE MOOD

Apply Burnt Sienna with your small sponge to deepen the warm glow along the edges of the midground, giving the scene a halo effect.

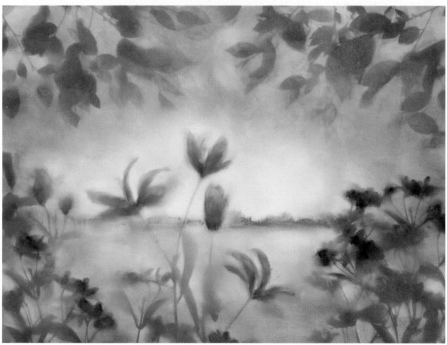

11| DETAIL THE FLOWERS

Double load your small sponge with Dioxazine Purple and Brilliant Purple and dab in color on the purple flower heads with a tightly pinched sponge, flipping the sponge to the clean side to blend and fade out the color a bit.

Detail the tiger lilies working from bottom to top. Apply Cadmium Red Medium starting at the bottom of the flower where it meets the stems, loading color in the corner and pinching the sponge to dab in the color then flipping the sponge to fade and blend color into the bloom.

Place Cadmium Red Light near the middle of the flower petal to create a gradated color change in each flower. Use Cadmium Orange to gradate the color as you move toward the tips of the petals. Finish the lilies with Cadmium Yellow Medium at the very tips of the petals.

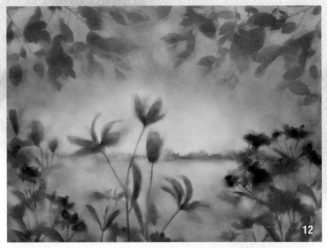

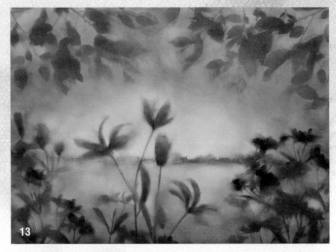

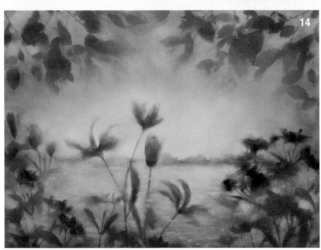

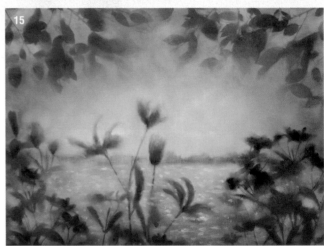

12| STRENGTHEN THE LEAVES

Use your small sponge with Sap Green to strengthen the leaves and stems that may have been lost. For the thin lines of stems use the edge of the sponge. If it gets too thick, use the clean side of the sponge to wipe out the excess color.

Add highlights to the edges of the leaves and stems with Light Yellow Green, pinching the sponge for a controlled, thin line.

13| ADD SOME SHADE

Make sure the bottom of the painting is dry, then apply Raw Umber with a small sponge as a shady color in the scene. Use circular strokes and flip to the clean side of your sponge to blend the color.

14| BRIGHTEN THE SKY AND DETAIL THE WATER

Use your small sponge to apply Unbleached Titanium in the middle area to brighten the sky. Drag color from the sky over the distant land to push the land back. Work over the bottom edges of the upper foliage area as well.

Use the same color to add short strokes for the ripples of the water, applying it with the edge of a small, tightly pinched sponge.

15| BRIGHTEN AND HIGHLIGHT

Use your small sponge with Titanium White to strengthen the clouds in the sky, going over the tops and edges of the flower petals to blend the flowers into the background so they don't look cut out. Add a few brighter ripples to the water.

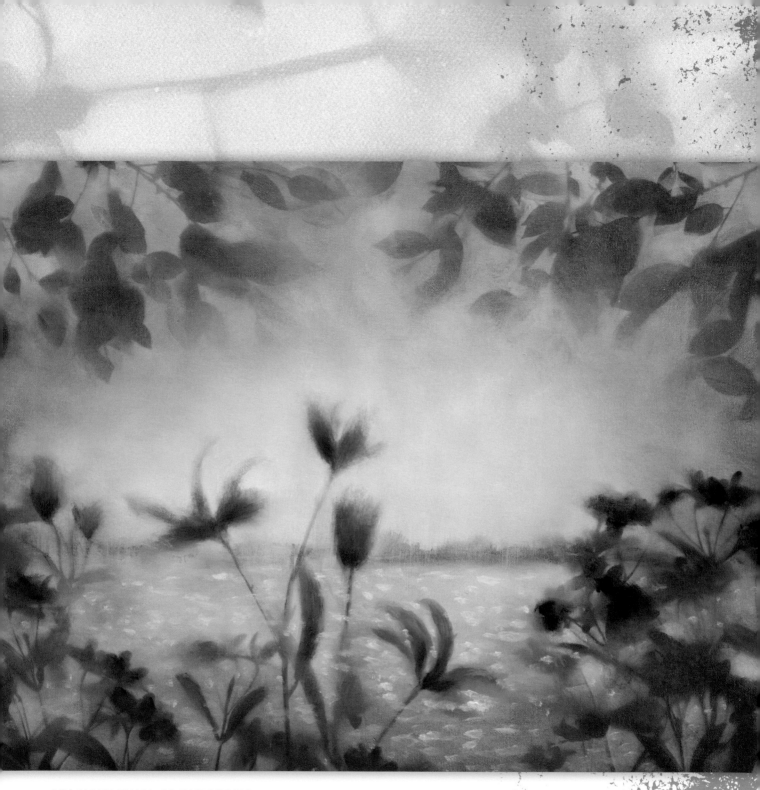

16| MAKE FINAL ADJUSTMENTS

The reds in the tiger lilies look fiery, so use your small sponge to apply
Burnt Sienna over the lilies to calm them down and give them a rusty color.

tigers at bay | acrylic and spray paint on 18" × 24" (46cm × 61cm) gessoed canvas

shell bottom

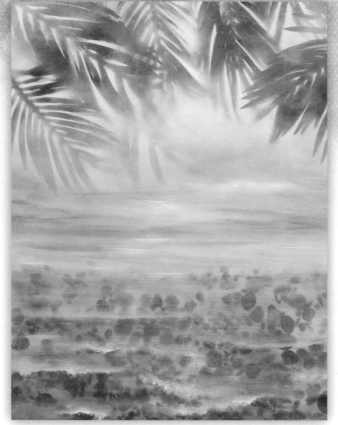

Real shells and palm fronds provide the foundation for this peaceful waterscape. As a final touch, you'll use the edge of your sponge to create gentle waves rolling over the shell bottom.

Bright Aqua Green

Brilliant Blue

Brilliant Purple

Burnt Sienna

Burnt Umber

Cadmium Orange

Cadmium Red Medium

Cadmium Yellow Medium

Hooker's Green Hue Permanent

Light Blue Permanent

Light Blue Violet

Naples Yellow

Phthalo Blue

Raw Sienna

Titanium White

Unbleached Titanium

Yellow Ochre

Sky Wash (Yellow Ochre + Raw Sienna)

materials

NATURAL OBJECTS
shells

PLASTIC PLANTS
palm fronds

SURFACE
24" × 18" (61cm × 46cm) gessoed canvas

1| APPLY THE PALM BASE COLORS
Wash on Hooker's Green with your large sponge, fading out the color as you go toward the bottom. Add some darker sections within the wash to vary the shade.

2| APPLY THE SHELL BOTTOM BASECOAT
Double load your medium sponge with Phthalo Blue and Burnt Umber, gently pinching as you apply these dark colors to the shell bottom. Don't mix these colors too much. But, as you near the top, blend and thin the wash.

3| DEVELOP THE PALM FROND BASECOAT
When the Hooker's Green dries, add Burnt Sienna over the Hooker's Green with your small sponge using circular strokes. It's OK if the green gets picked up here and there and blends or gets lighter. This will give variety of value under the spray coat to come.

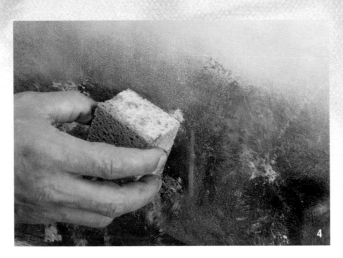

4| DEVELOP THE SHELL BOTTOM BASECOAT

Double load your small sponge with Cadmium Orange and Cadmium Yellow Medium and dab the color onto the area of the shell bottom.

Add even more color, double loading your small sponge now with Cadmium Red Medium on one side and Raw Sienna mixed with a little Unbleached Titanium on the other side. Dab it on and let it dry.

5| COMPOSE AND PLACE YOUR PROPS

Place the palm fronds at the top and scatter the seashells at the bottom.

6| SPRAY THE DESIGN

Hold down any props that are rising too high from the surface as you spray so you get a good masking of the objects.

7| START THE SKY AND WATER

Wash Light Blue Permanent into the sky area with your medium sponge using circular strokes. Blend into the palms and fade as you come down into the middle of the painting.

Use this same color and horizontal strokes to establish the horizon line, blending and fading color into the shell area.

8| WARM UP THE SKY

Come in next to the middle ground with Raw Sienna on your medium sponge, blending the sky and water together, and giving warmth to the sky.

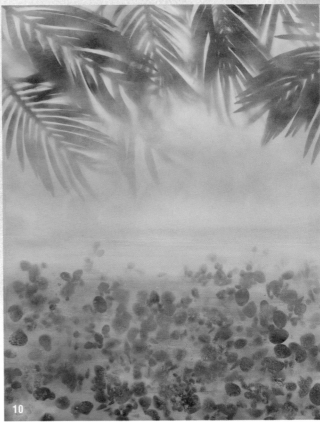

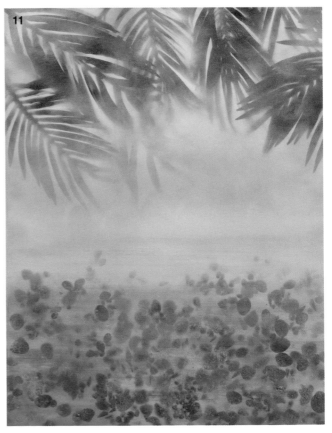

9| ADD DEPTH TO THE WATER

Wash Light Blue Violet into middle part of the water with your medium sponge.

10| GREEN UP THE WATER

Apply Bright Aqua Green from the bottom up. Use horizontal streaks through the water area, moving up and flipping the sponge to blend a bit, but leaving the strokes visible.

11| GO DARKER

Stroke horizontal color with the edge of your medium sponge using Brilliant Blue, flipping to the clean side to blend just a bit as needed.

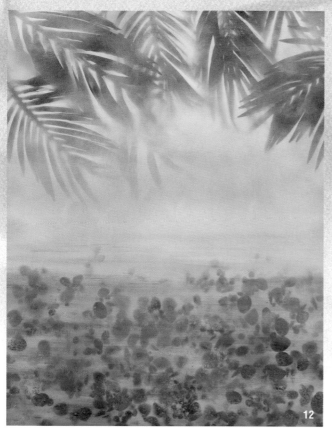

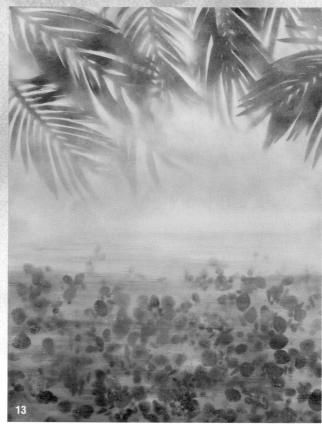

12| ADD MORE GREEN

Use Hooker's Green to deepen the green in the water here and there, again using the edge of the sponge to apply color, and then the back of the sponge to blend out the color.

13| ADD MORE DEPTH

Apply Phthalo Blue sparingly, mostly in the foreground (the very bottom of the painting).

14| BRIGHTEN THE SKY

Use a small sponge to apply Naples Yellow to the sky and as reflections in the upper part of the water. Apply with horizontal strokes, flipping to blend out the color.

15| ADD CONTRAST

Add some contrast to the yellow sky by adding Brilliant Purple in the horizon area. Use a small sponge and apply with horizontal strokes, then flip to blend.

16| DEEPEN THE SKY

Apply the Sky Wash here and there in the sky to deepen.

17| CREATE A GLOW

Use horizontal strokes of Unbleached Titanium to develop a light glow in the sky, to add in clouds, and to place some reflections in the top area of the water.

18| ADD GENTLE WAVES

Apply Titanium White over the Unbleached Titanium to strengthen the light in the sky and reflections in the water.

Add waves with your small sponge and the Titanium White, painting heavy at the bottom of the wave edge and flipping to blend out color at the top of the shape so the bottom has a hard, white edge. As the waves come closer to the foreground, just dab in the bottom wave edge and flip to blend the top into the water.

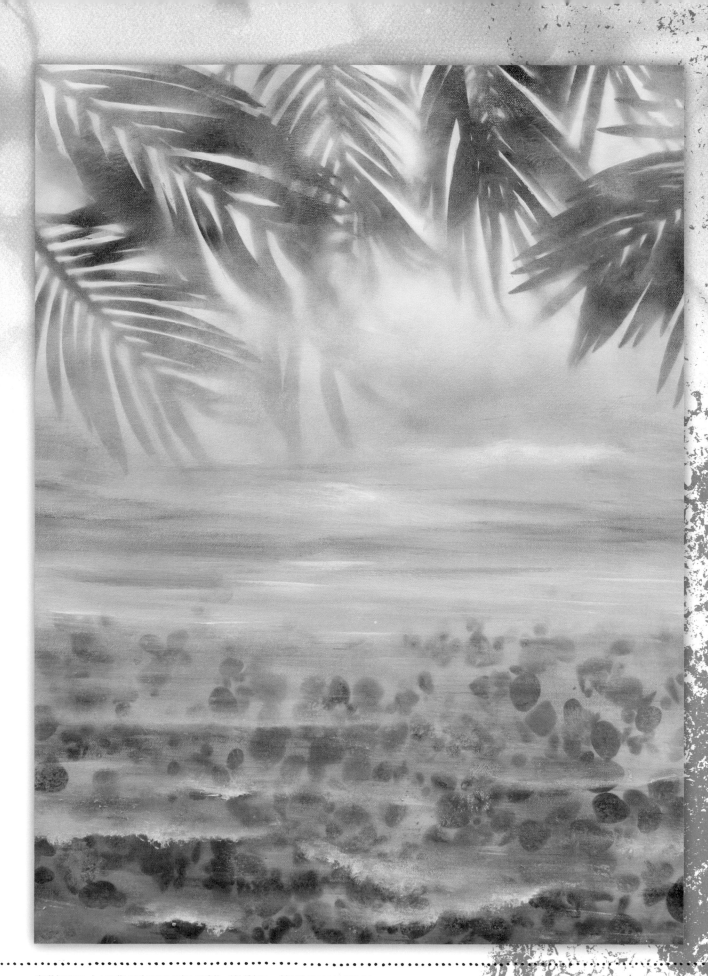

shell bottom | acrylic and spray paint on 24" × 18" (61cm × 46cm) gessoed canvas

oaken perch

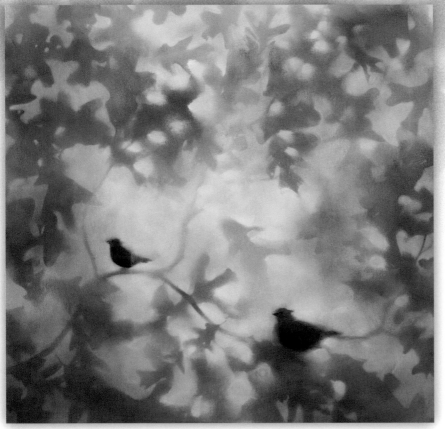

The complementary color schemes of autumn make for paintings that design themselves! To create this intimate scene, a rich, warm basecoat of umber and siennas serves as foliage, with beautiful blues shining through to portray glimpses of the sky above. The addition of two lively cardinals brings the painting to life.

materials

FOUND OBJECTS
model birds

NATURAL OBJECTS
oak leaves and branches

SURFACE
24" × 24" (61cm × 61cm) gessoed canvas

Burnt Sienna

Burnt Umber

Cadmium Red Light

Cadmium Red Medium

Cerulean Blue

Dioxazine Purple

Light Blue Permanent

Raw Sienna

Titanium White

Dark Purple
(Burnt Sienna +
Dioxazine Purple)

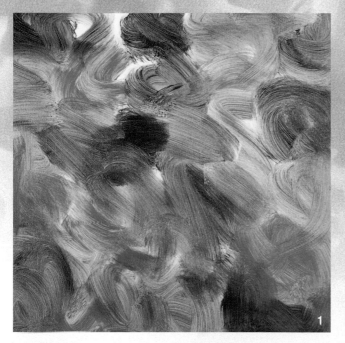

1| ADD THREE SEPARATE COLORS AS THE BACKGROUND

Mottle in Raw Sienna, Burnt Umber and Burnt Sienna using circular strokes and a medium sponge. Go wild with it.

2| BLEND THE BACKGROUND COLORS

Come in with a large, clean, moist sponge and blend the colors together. Let dry.

3| APPLY THE BASECOAT FOR THE BIRDS

Use Cadmium Red Medium and your medium sponge to paint the areas where you will place your birds. Let dry.

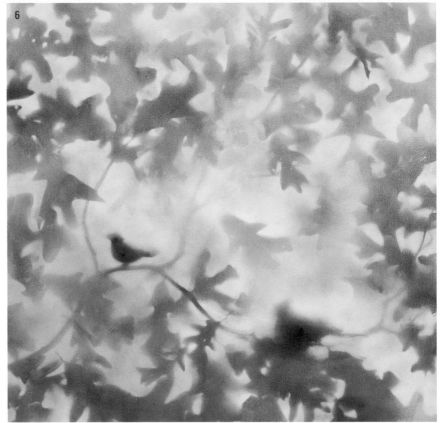

4| COMPOSE AND PLACE PROPS

Compose branches, oak leaves and model birds on the background. Use as many birds as you like and place them on top of the areas you previously painted red.

5| SPRAY THE DESIGN

Spray right over your props in short bursts, holding down any props that are rising too high from the surface so you get a good masking of the objects. Let this dry, then remove the materials.

6| APPLY THE SKY COLOR

Use a medium sponge to add sky patches with Light Blue Permanent, dabbing in color between the leaves and then blending it out in a circular motion. It is OK to go over the leaves in some areas. Add Cerulean Blue in some areas to deepen and add variety.

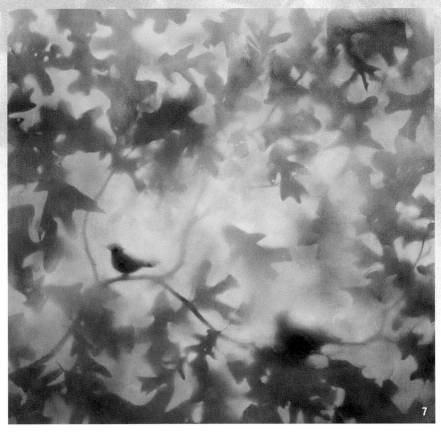

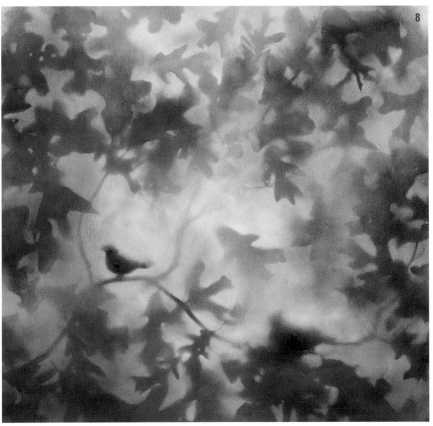

7| DARKEN THE FOLIAGE
Darken some leaf areas using your medium sponge and Burnt Sienna, applying with a circular motion and blending the color into the painting.

8| PUSH THE FOLIAGE DARKER STILL
Follow up with Burnt Umber over the leaf area to further deepen and add variety, blending the color into the painting.

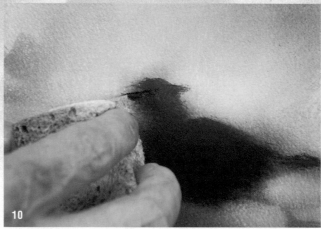

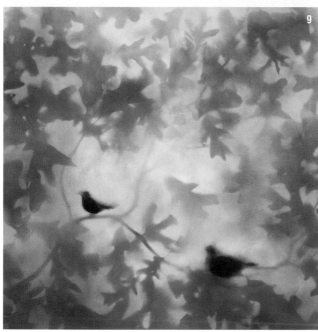

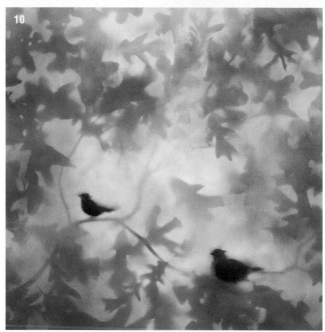

9| DEVELOP THE BIRDS

Use a small sponge and Dioxazine Purple to darken some areas in the cardinals. Pinch the sponge to apply dark color at the bottom, then flip and blend up into the bird. Wipe out color as needed if you lose too much red.

Use your small sponge to block in the wing and highlight the head and tail with Cadmium Red Medium.

10| FINISH THE BIRDS

Using your small sponge, apply Cadmium Red Light over the wings and top of the head. Use Dioxazine Purple to paint the details on the faces using the very corner of the sponge for the beak and eye.

11| PUSH THE FOLIAGE DARKER STILL (OPPOSITE PAGE)

Use your small sponge to apply Titanium White between the leaves to portray the sunlight coming through the foliage, bringing out leaves using a negative painting technique. Dab in the color, then flip the sponge to blend as you work throughout the painting.

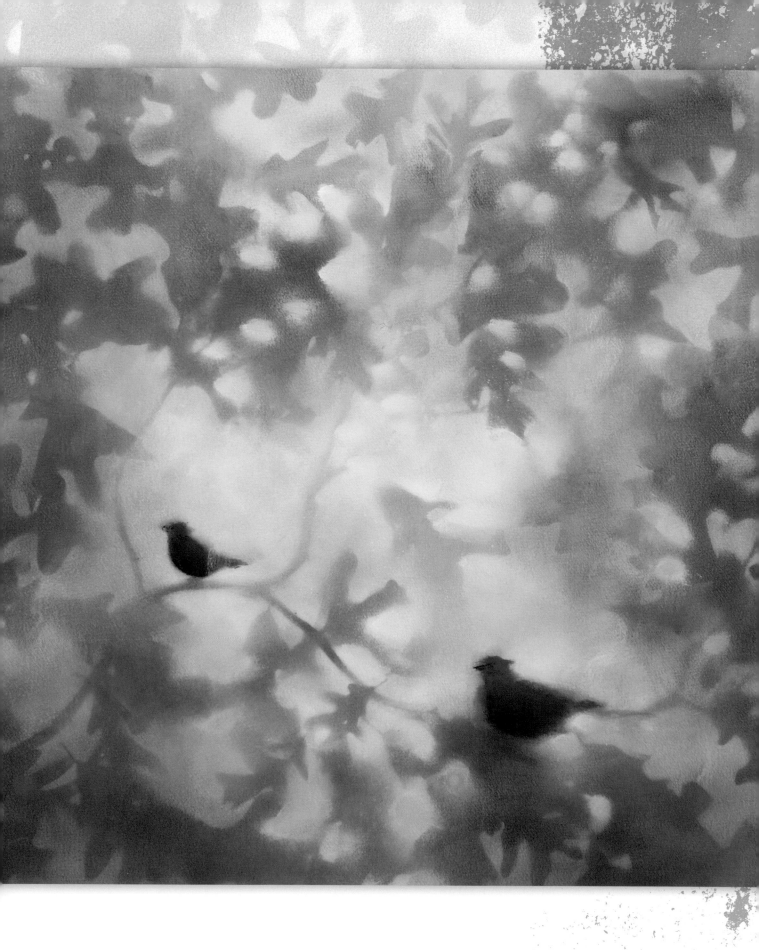

oaken perch | acrylic and spray paint on 24" × 24" (61cm × 61cm) gessoed canvas

autumn solace

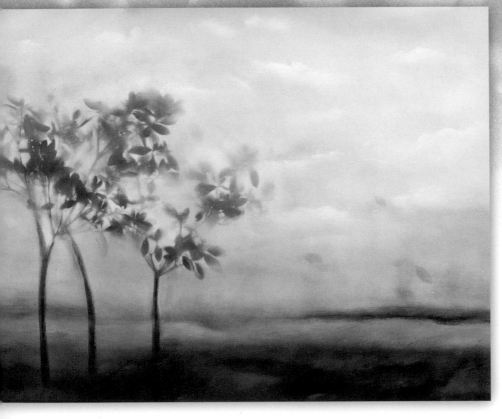

You can almost feel the brisk autumn winds blowing in this painting. The composition and colors you use in this demonstration will be key to creating this strong, moody scene.

materials

NATURAL PLANTS
twigs with small leaves

SURFACE
18" × 24" (46cm × 61cm) gessoed canvas

Brilliant Blue

Brilliant Purple

Brilliant Yellow Green

Burnt Sienna

Burnt Umber

Cadmium Orange

Cadmium Red Medium

Light Blue Permanent

Light Blue Violet

Raw Sienna

Raw Umber

Sap Green

Ultramarine Blue

Unbleached Titanium

Distant Land (Brilliant Blue + Burnt Umber)

Distant Land Highlight (Brilliant Blue + Burnt Umber + Titanium White)

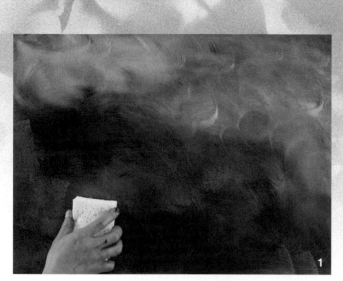

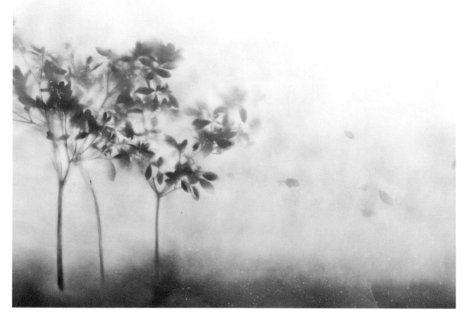

1| APPLY THE BASECOAT

Spray the canvas lightly and use your medium sponge to mottle in Burnt Sienna all over and Cadmium Red Medium in the lower left section of canvas. Use a clean, large, wet sponge to blend the colors. Let this dry.

2| COMPOSE THE PAINTING

Place the twigs toward one side of the canvas in a small cluster. Scatter some loose leaves across the space of the canvas as if they were blowing in the wind.

3| SPRAY YOUR DESIGN

Hold down any props that are rising too high from the surface as you spray so you get a good masking of the objects. Leave some unsprayed area toward the bottom to designate the land.

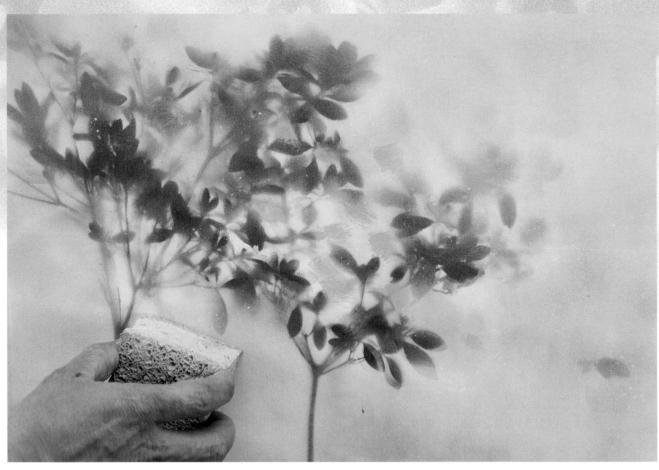

4| PAINT THE SKY

Spray the sky area lightly with water. Then apply Light Blue Violet with circular strokes using your medium sponge—keep the color heavy at the top, fading down as you go. Work around the trees by pinching the sponge to dab in color and then flipping to blend.

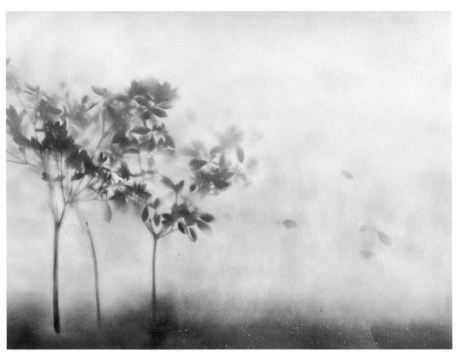

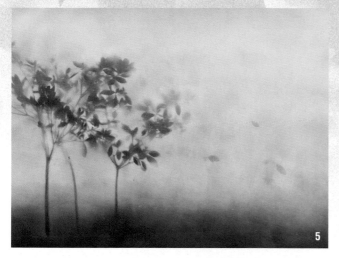

5| PAINT THE FOREGROUND

Apply Burnt Sienna with your medium sponge, heavy at the bottom and fading out the color as you move up into the sky area.

6| DEVELOP THE DISTANT LANDMASS

Mix Brilliant Blue with Burnt Umber and use a medium sponge to lay in the distant landscape with a short, angled, back-and-forth motion.

7| HIGHLIGHT THE DISTANT LANDMASS

Add Titanium White to the mix from step 6, and paint a lighter value in the distance.

Add more white to this mix and add another lighter value to the distant landscape using small strokes with the medium sponge.

8| WARM UP THE DISTANT LANDMASS

Put Sap Green in the middle section of the landscape using the corner of a small sponge, then come in to this area with a thin line of Brilliant Yellow Green.

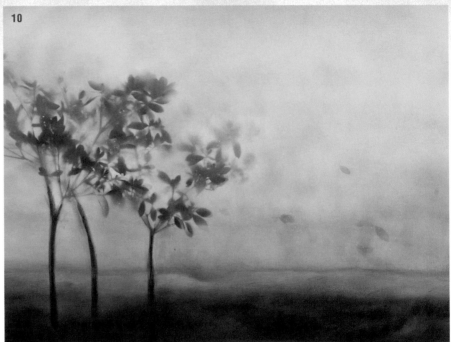

9| ADD WARMTH TO THE SKY

Use your medium sponge to lay in Raw Sienna with horizontal strokes as a distant glow over the landscape. It's OK to come down over the green.

10| DEVELOP THE TREE TRUNKS AND FOREGROUND LAND

Use Burnt Umber to add tree trunks with the edge of your small sponge, wiping out color with the clean side of the sponge as needed to keep the desired thickness.

Use the same color and sponge to add shadowing in the foreground grass using a quick, short up-and-down stroke with the edge of the sponge. Do this again with Burnt Sienna to add more shadowing and color variation.

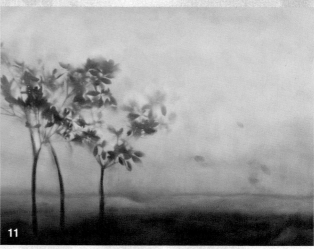

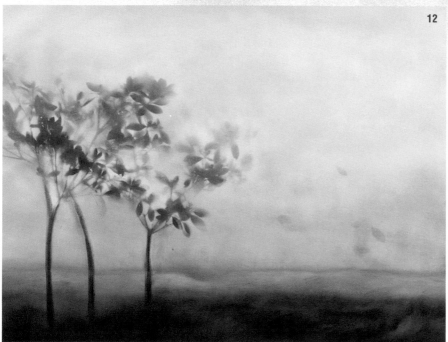

11| ADD CLOUDS

Use Unbleached Titanium to add clouds in the sky with your small sponge, putting heavier color at the top with a tight pinch and then flipping to fade out the clouds at the bottom. Add color between the tree branches as well.

12| REBUILD THE SKY COLOR

Use a small sponge and Light Blue Permanent to bring back some of the blue in the sky throughout, even between tree branches. Dab in the color, then flip to blend.

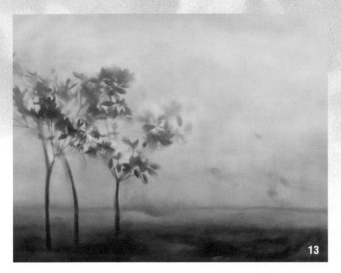

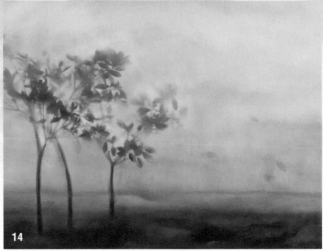

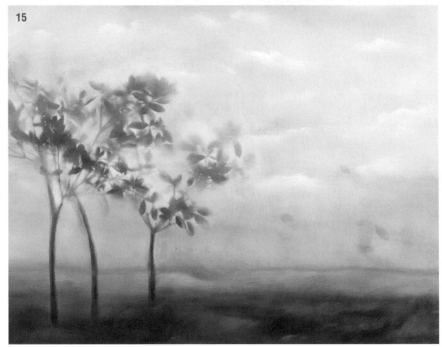

13| BRIGHTEN THE FOREGROUND

Use a small sponge to add a little Cadmium Orange in the foreground, dabbing it in to add brighter spots in the grass area.

14| ADD VARIETY TO THE SKY

Add Brilliant Purple to the sky in some areas for variety using a dry sponge technique with your small sponge.

15| HIGHLIGHT THE CLOUDS

Use Titanium White to place highlights on top of clouds with the edge of your small sponge, blending down to the bottom of each cloud.

16| ADD THE FINAL TOUCH (OPPOSITE PAGE)

Use Raw Umber with a gently pinched small sponge to add a distant horizon line. Then add Burnt Sienna there as well to give a little variety of color.

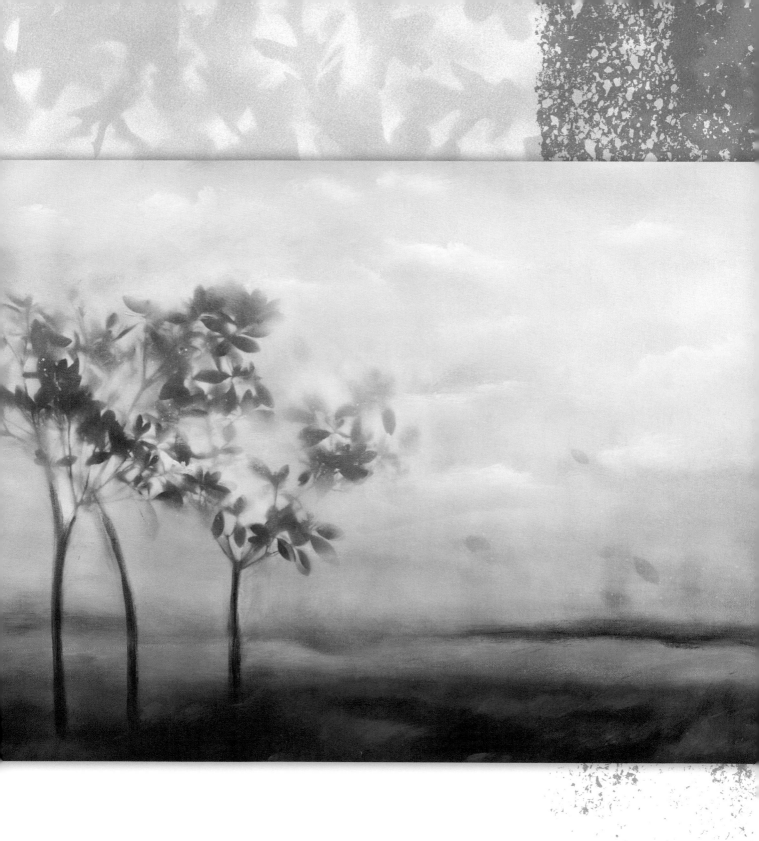

autumn solace | acrylic and spray paint on 18" × 24" (46cm × 61cm) gessoed canvas

mid-autumn stroll

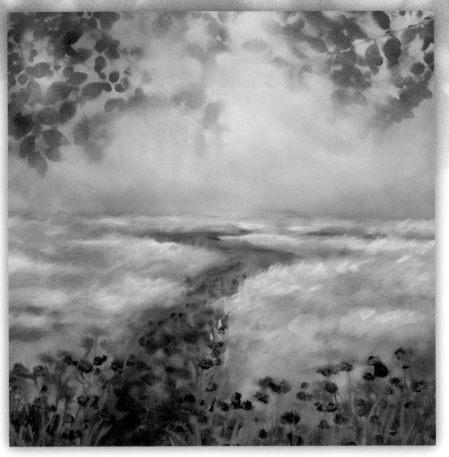

A detailed basecoat creates the foundation for this lovely autumn scene. You'll learn to use your sponge to create swaying grasses and brilliant flowers to complete the picture.

materials

NATURAL PLANTS
ficus leaves and branches
rocks

SILK PLANTS
small wildflowers

SURFACE
24" × 24" (61cm × 61cm)
gessoed canvas

Brilliant Purple

Burnt Sienna

Burnt Umber

Dioxazine Purple

Light Blue Violet

Naples Yellow

Phthalo Blue

Raw Sienna

Raw Umber

Sap Green

Titanium White

Unbleached Titanium

Yellow Ochre

1 | APPLY THE BASECOAT FOR THE OVERHANGING TREES

Wet the canvas lightly with clear water, then use your small sponge to mottle in Burnt Umber, Burnt Sienna and Sap Green using circular motions.

Blend with a large, clean, wet sponge, flipping the sponge over to the clean side to fade out at the bottom.

2 | APPLY THE BASECOAT FOR THE PATH

Block in the road with Burnt Sienna using your small sponge.

Double load a small sponge with Phthalo Blue and Burnt Umber and mottle in rocky texture, dabbing on and placing short streaks of color.

Add still more mottled texture with Burnt Umber and Raw Umber, then Burnt Sienna and Unbleached Titanium.

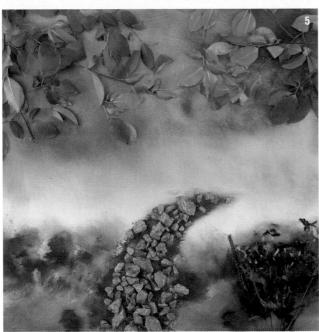

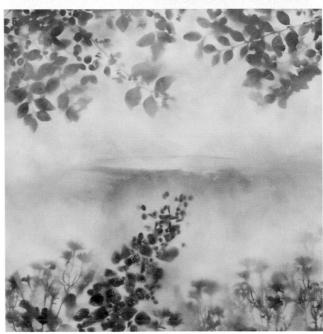

3| PAINT THE BASECOAT FOR THE FOREGROUND

Use your small sponge to add Sap Green to both lower sides for foliage, washing in color with a circular motion and flipping the sponge to the clean side to fade up toward the midground.

4| PAINT THE FLOWER BASECOAT

Double load a small sponge with Dioxazine Purple and Brilliant Purple to paint the base for the flowers using small, circular strokes. Blend and fade the purples into the green. Let dry.

5| COMPOSE THE PAINTING

Place the branches and foliage at the top to portray overhanging trees. Scatter some small rocks along the path. Use small sprigs of flowers in the foreground.

6| SPRAY YOUR DESIGN

Hold down any props that are rising too high from the surface as you spray so you get a good masking of the objects. If you have only one bouquet of flowers, spray it in one place, then move it to a new place and spray again.

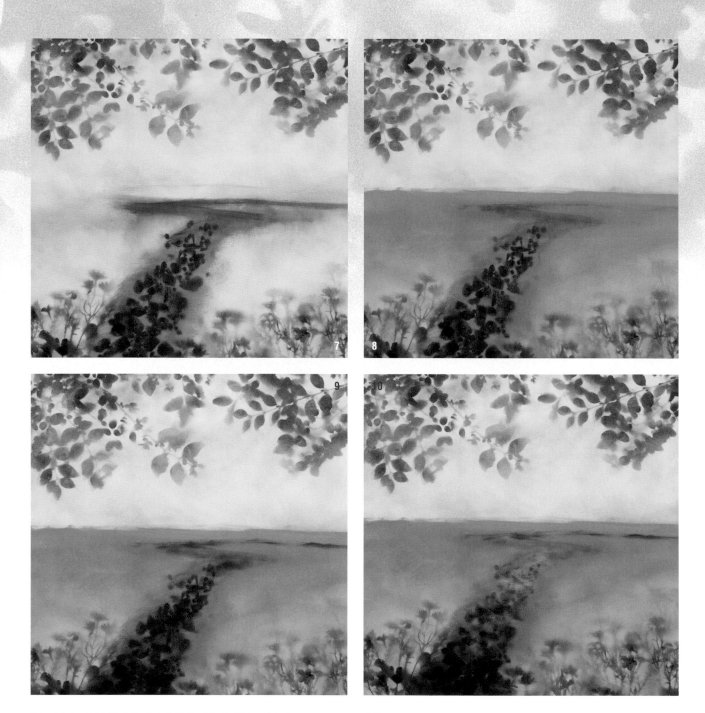

7| ADD ANOTHER BASECOAT TO THE PATH

Add a light wash of Raw Umber over the rocky path with a small sponge, extending it into the distant horizon.

8| ADD ANOTHER BASECOAT TO THE FIELD

Block in the field area with Yellow Ochre on your small sponge, starting at the top and working down the painting to the foreground, fading into the flowers.

9| DEVELOP THE PATH

Use Burnt Umber and your small sponge to add some dark spots to the path. Do the same with Burnt Sienna, dabbing on color (no blending).

10| FINISH THE PATH

Finish the rocky road with Unbleached Titanium, using the corner of your small sponge to paint around some of the individual rocks, washing over others, and then flipping over to blend in some areas.

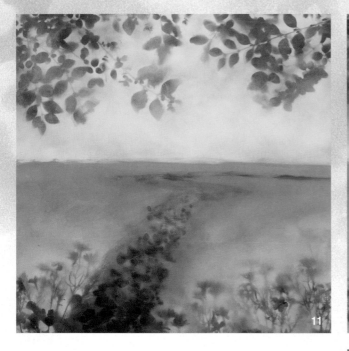

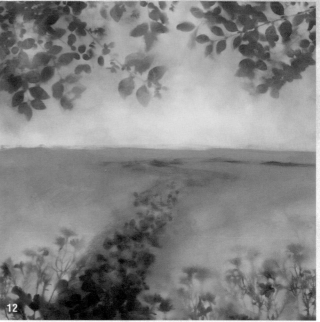

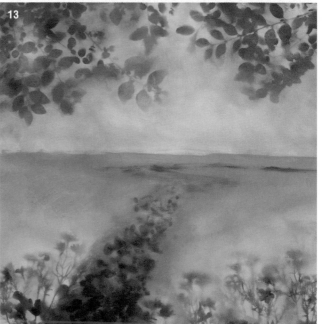

11| BRING COLOR BACK INTO THE FOLIAGE
Use your small sponge to blend Sap Green into the upper leaf area.

12| DEVELOP THE FOLIAGE COLOR
Do the same with Burnt Sienna and Raw Sienna.

13| BRING FOLIAGE DOWN INTO THE SKY
Use Sap Green, Burnt Sienna and Raw Sienna to mottle in the lower foliage, bringing some of the siennas down into the sky area.

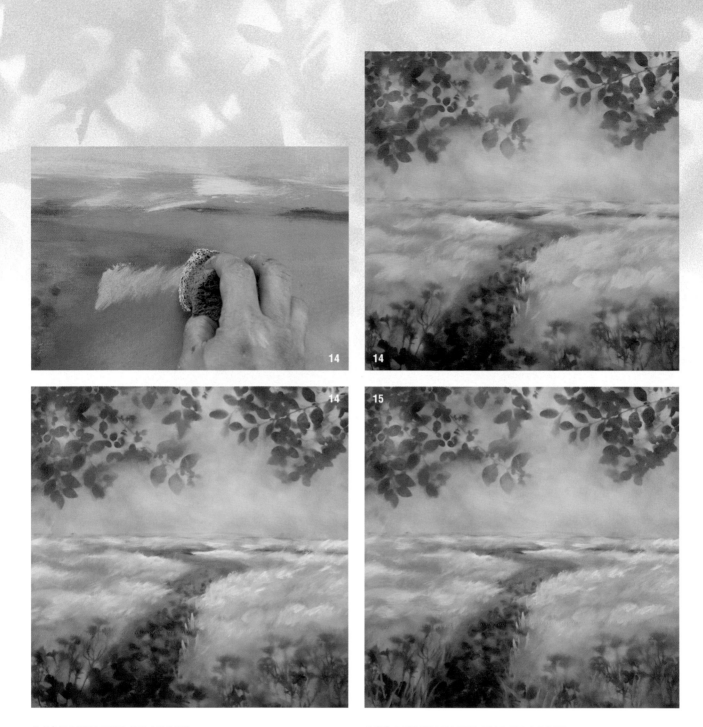

14| PAINT THE GRASSES

Add grasses to the land with Naples Yellow using short quick strokes with a gently pinched sponge.

Add Titanium White to the yellow to highlight and build the grassy land with a variety of shades. Let dry.

15| REESTABLISH THE GRASSES

Go back in with Yellow Ochre and your small sponge here and there over the white to bring back some of the darks. Add some longer grass in the foreground with the edge of the sponge using long, vertical strokes.

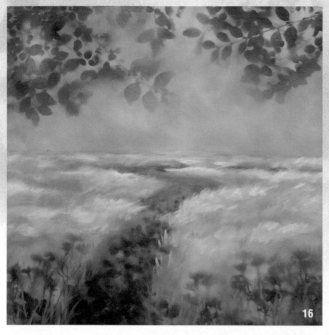

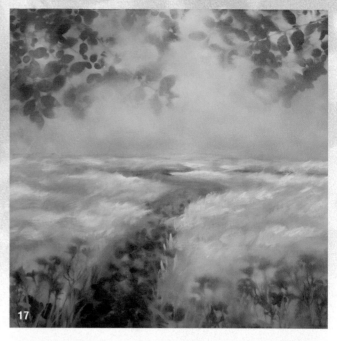

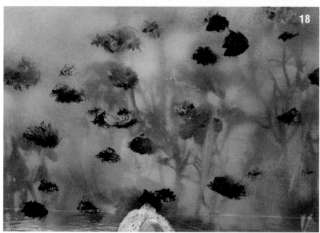

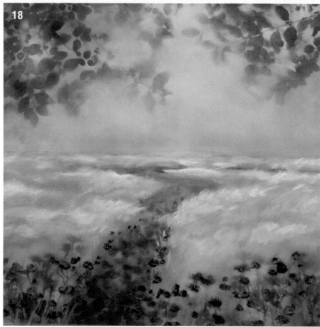

16| ADD COLOR TO THE SKY

Use Light Blue Violet to lay in the sky color with your small sponge using circular strokes, coming down and blending over the horizon line in some areas.

17| ADD A GLOW TO THE SKY

Use Unbleached Titanium and your small sponge to paint around the front upper leaves to give them shape against the sky, flipping the sponge to blend underlayers together in the sky.

18| PAINT THE FLOWERS

Use the very corner of your small sponge and Dioxazine Purple to detail the foreground flowers, adding a layer of Brilliant Purple to highlight.

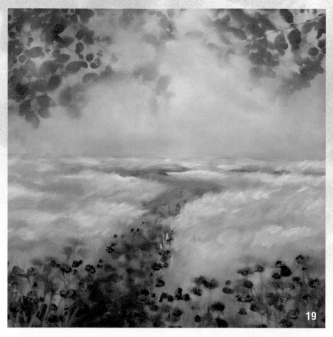

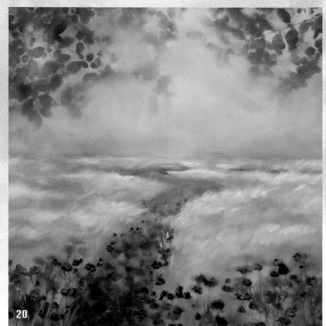

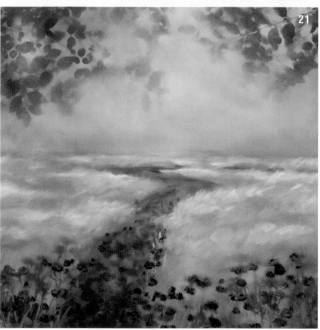

19| BRIGHTEN THE SKY

Come in with Titanium White to strengthen the white in the sky. Use your small sponge and wash around the leaves and down to the horizon.

20| ADD DISTANT LAND

Use your small sponge and Sap Green to add distant land thinly at the horizon line, fading it into the sky, and washing some into the grass area.

21| ADD MORE DEPTH TO THE PATH

Use Raw Umber to deepen the land on the path, using the corner of your small sponge to paint between rock shapes.

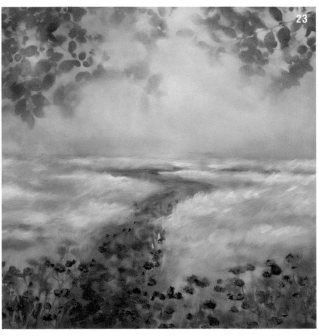

22| ADD MORE DEPTH TO THE FOREGROUND
When the foreground flowers are dry, use Burnt Sienna to darken the foreground. Use the corner of your small sponge to go between the spaces of the flowers. Extend some of the sienna into the midground as well.

23| FINISH WITH FOREGROUND DETAILS
Add more grass to the foreground with Yellow Ochre using the edge of your small sponge to paint long, vertical strokes.

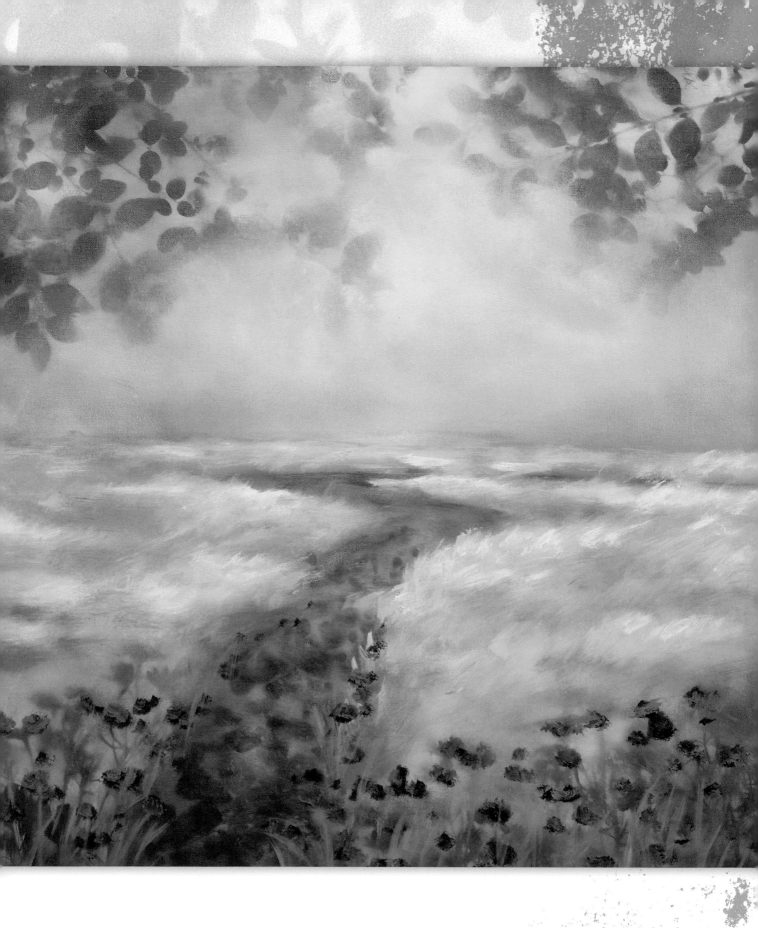

mid-autumn stroll | acrylic and spray paint on 24" × 24" (61cm × 61cm) gessoed canvas

autumn romance

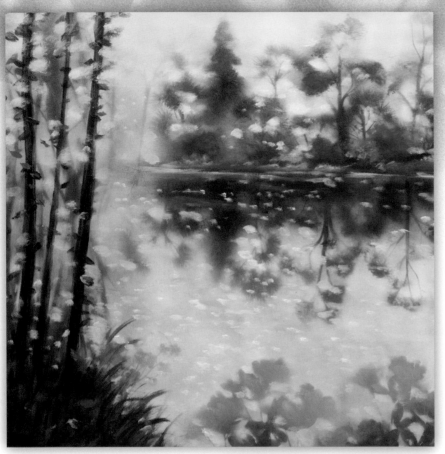

What better way to show off the brilliance of autumn's colors than to paint the bright foliage twice—once on the trees and again in a sparkling lake reflection?

materials

NATURAL PLANTS
small branches

SILK OR PLASTIC PLANTS
small- and medium-sized flowers
small aquarium plants

FOUND OBJECTS
model train trees

SURFACE
24" × 24" (61cm × 61cm)
gessoed canvas

Brilliant Blue

Burnt Sienna

Burnt Umber

Cadmium Orange

Cadmium Red Light

Cadmium Yellow

Light Blue Permanent

Light Blue Violet

Medium Magenta

Raw Sienna

Sap Green

Titanium White

Ultramarine Blue

Unbleached Titanium

*Distant Land
(Brilliant Blue +
Burnt Umber)*

*Distant Land Highlight
(Brilliant Blue + Burnt
Umber + Titanium White)*

1| PAINT THE OVERALL BACKGROUND AND TREE AREAS

Mist the canvas lightly with clear water and apply Raw Sienna over the entire canvas with a large sponge. Let this dry.

2| PAINT THE TREE AREAS

Use your large sponge to add Burnt Sienna to the tree area in the midground, and Burnt Umber to the tree area on the left side of the canvas.

3| BASECOAT THE MIDGROUND TREES

Add Sap Green for the evergreens and their reflection using a side-to-side stroke with your small sponge. Add other tree shapes, as well as small streaks or circular areas.

4| BASECOAT THE FOREGROUND FOLIAGE

Block in the lower right corner with Sap Green using circular strokes and your small sponge.

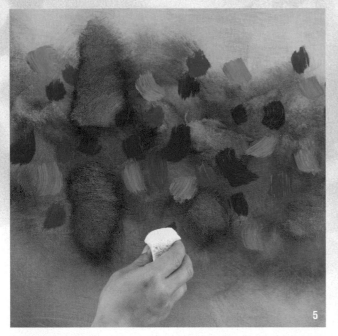

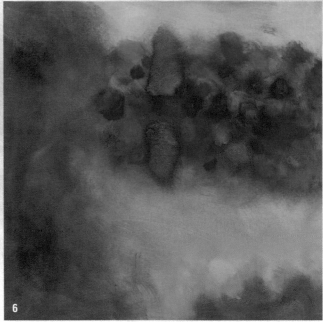

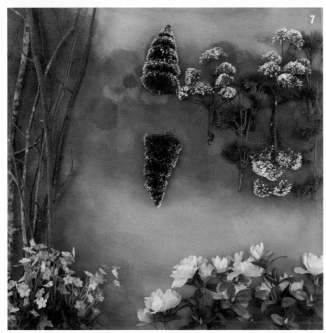

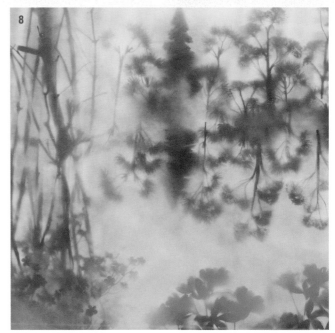

5| ADD COLOR TO THE MIDGROUND

Mottle in Cadmium Red Light, Cadmium Red Medium and Cadmium Orange with your gently pinched small sponge.

6| FINISH THE BASE LAYERS

Before the autumn color dries in the midground, use a clean sponge to blend the colors somewhat.

Block in the lower right flower base with your small sponge and Light Blue Violet and let this dry.

7| COMPOSE THE PAINTING

Compose branches, aquarium plants, model train trees and silk flowers on the background. Think about the reflection in the water and make sure to place objects as they would actually be reflected.

8| SPRAY YOUR DESIGN

Hold down any props that are rising too high from the surface as you spray so you get a good masking of the objects. There are a lot of props here; if you don't have enough and need to reuse some, it's OK to spray, move and spray in a new place.

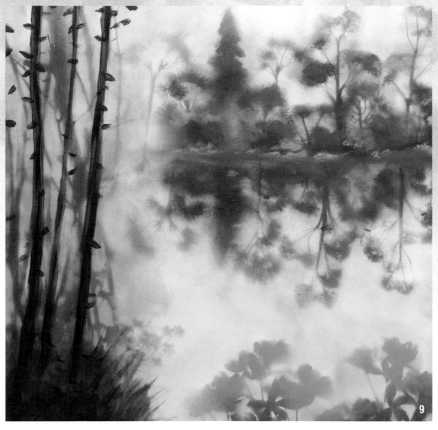

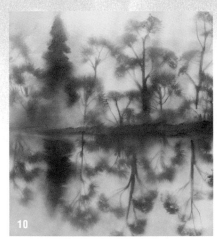

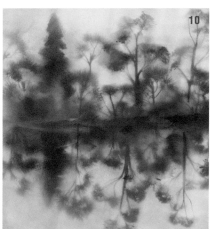

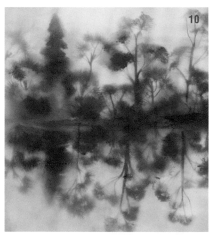

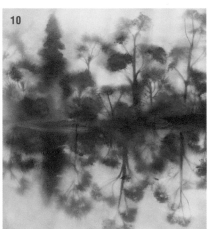

9| DARKEN THE LANDMASSES

Apply Burnt Umber with your medium sponge in the left tree area, darkening the landmass and trees. Keep the color darker at the bottom and pick up color with the edge of your sponge to portray grasses. Also, pick up color between the branches in the trees. Then add solid tree trunks with Burnt Umber using your small sponge.

Use Burnt Umber to add a landmass on the right between the lake and the trees. Use horizontal strokes and blend the color into the water.

10| REESTABLISH FOLIAGE

Using the same colors you used in the background wash, deepen the colors of the trees and their reflections with your small sponge (keep the same value for the actual objects and their reflections).

Use Sap Green in the evergreens and their reflections.

Layer Cadmium Red Medium, Cadmium Red Light, and then Cadmium Orange in the foliage and reflections, dabbing in color and not blending too much.

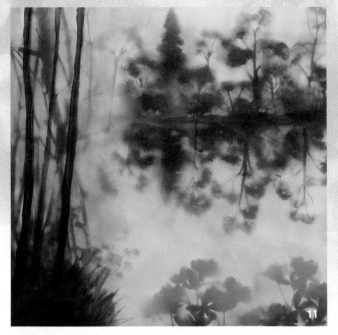

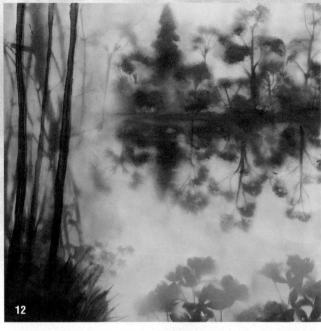

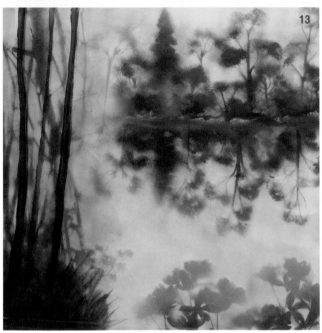

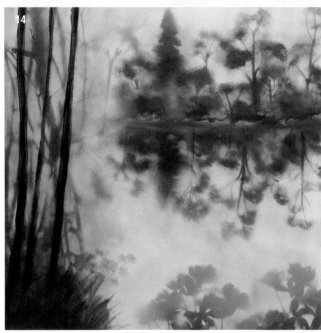

11| ADD FOLIAGE HIGHLIGHTS

Finish the foliage in the midground using your small sponge to apply Cadmium Yellow highlights throughout the foliage and reflections.

12| ADD COLOR TO THE MIDGROUND LANDMASS

Mix Brilliant Blue and Burnt Umber (60/40—more to the blue side) to make a dark green and go over the background landmass with your small sponge, using the corner of the sponge to blend the outer edges of the land into the trees and water.

13| HIGHLIGHT THE MIDGROUND LANDMASS

Add some Titanium White to the blue/umber mix from step 12 to make a lighter version of this color to highlight the landmass here and there. Dab in color with your small sponge, flipping to the clean side to soften.

14| DEVELOP THE TREE TRUNKS ON THE LEFT

Using a small sponge, start with Burnt Sienna to highlight and add form to the tree trunks. Then add a shadow side with Ultramarine Blue, just placing spots of color here and there.

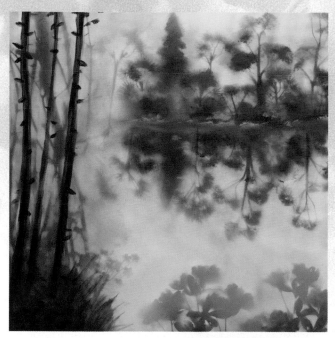

15 | ADD FOLIAGE TO THE TREES ON THE LEFT

Use the corner of your small sponge to apply leaves in the trees and scattered on the ground on the left side of the painting.

Start with Cadmium Red Medium, then apply Cadmium Red Light and Cadmium Orange in the same manner. Add some Sap Green leaves as well, placing a little Cadmium Yellow highlight on each green leaf.

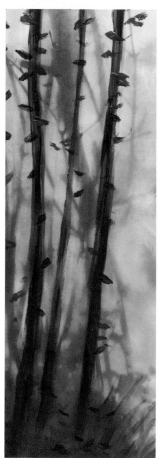
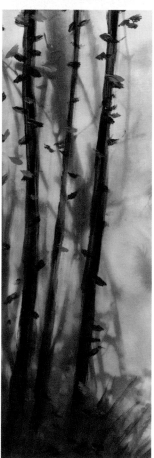

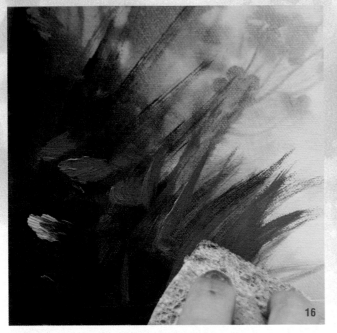

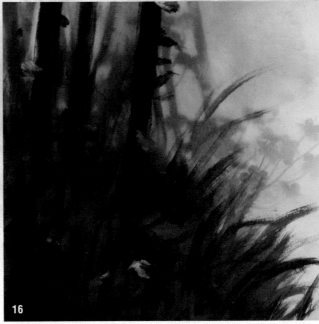

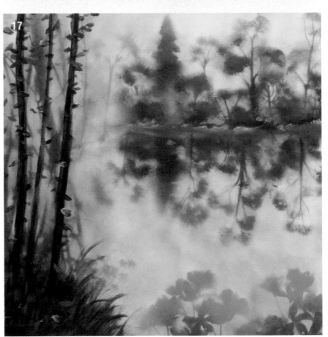

16| ADD GRASSES TO THE LANDMASS ON THE LEFT

Use a small sponge and Raw Sienna to detail the left landmass. Use the edge of your small sponge to pull up some grass shapes in the land under the left-side trees using Raw Sienna and Burnt Sienna.

Do the same with Sap Green, adding random spots of green with the corner of the sponge, and a little bit of grass with the edge of the sponge. Let this dry.

17| WASH OVER THE WATER AND SKY

Use a medium sponge to place a light wash of Medium Magenta over the white areas in the sky and water—it's OK to paint over trees in some areas. Flip the sponge to the clean side to blend in color. Use the edge of your sponge to work color between the tree branches on the left. Keep this wash thin. Let dry.

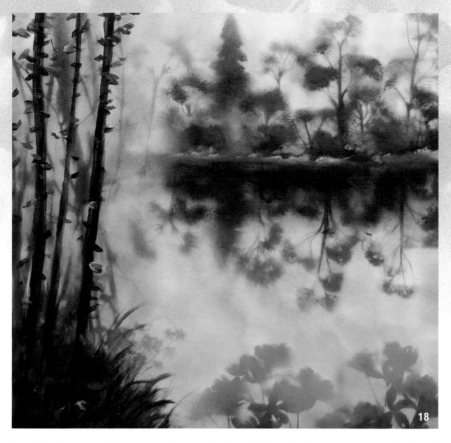

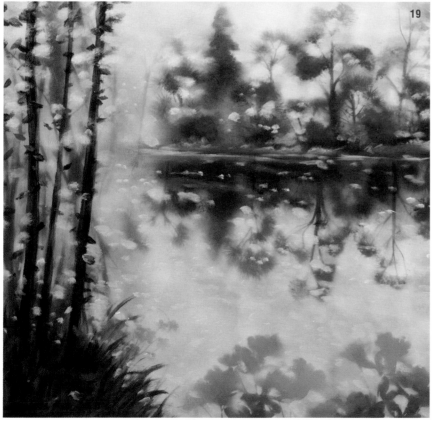

18| DEEPEN THE REFLECTION OF THE LAND

Use Burnt Umber and your medium sponge to shadow the water where it meets the land. Start applying the color at the land with the sponge edge, then flip it to the clean side to fade color down and blend into the water.

19| ADD HIGHLIGHT SUN SPARKLES

Use your small sponge and Unbleached Titanium to spot in all the sunlight popping through the distant trees. Dab in color, then flip to blend a bit, but leave a spotty look here and there. Do the same in the trees on the left.

Apply white horizontal strokes in the water near the landmass to add the sun's reflection in the water, then add various sized spots of sun on the water with the tiny corner of your small sponge or with the center of a tightly pinched sponge to vary the size of the stroke. Place dots of white behind the tree trunks on the left and the flowers on the right to show the sparkling water peeking through the trees and flowers.

20| HIGHLIGHT THE BLUE FLOWERS

Use Light Blue Permanent to highlight the flowers on the lower right side with your small sponge.

21| COMPLETE THE PAINTING BY BRIGHTENING SUN SPARKLES

Use Titanium White and the corner of your small sponge to go back in and add more sunny highlights here and there in the foliage and on the water.

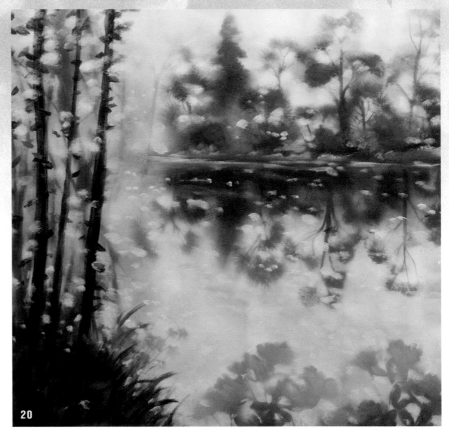

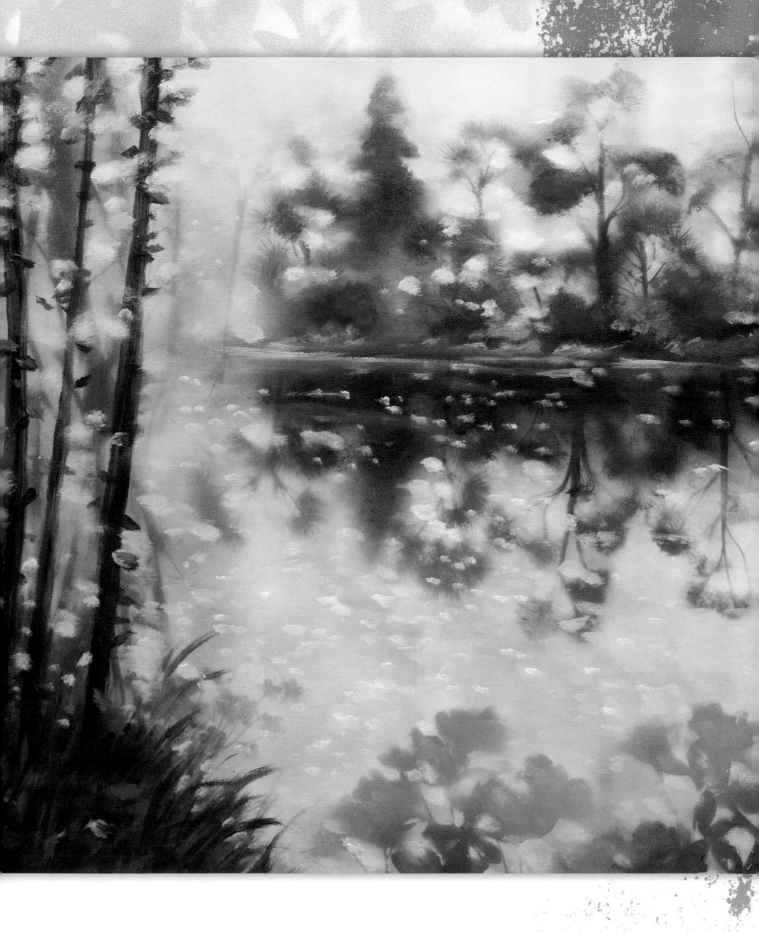

autumn romance | acrylic and spray paint on 24" × 24" (61cm × 61cm) gessoed canvas

winter haze

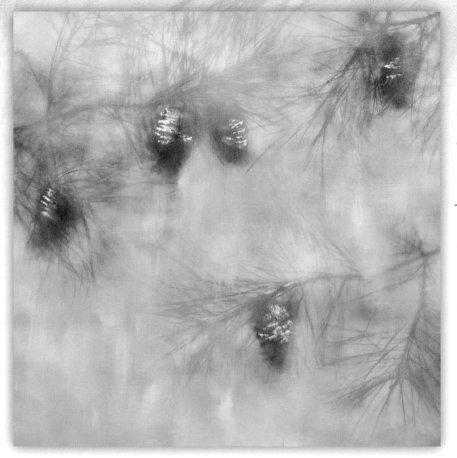

Crosshatching is an easy way to give the feeling of snow and ice to this painting. This feeling will be emphasized all the more by using traditional pine branches and pinecones as your props.

materials

NATURAL PLANTS
pine boughs
pinecones

SURFACE
24" × 24" (61cm × 61cm) gessoed canvas

Burnt Sienna

Burnt Umber

Light Blue Violet

Raw Umber

Sap Green

Titanium White

Unbleached Titanium

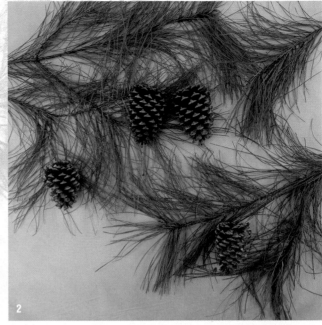

1| PAINT THE OVERALL BACKGROUND

Mist the canvas lightly with clear water and use your large sponge to apply Light Blue Violet over the entire surface with circular strokes. Let dry.

2| COMPOSE THE PAINTING

Compose the pine boughs and pinecones to make it look like a close-up of part of an actual tree.

3| SPRAY YOUR DESIGN

Hold down any props that are rising too high from the surface as you spray so you get a good masking of the objects.

4| ADD SOME COLOR TO THE BRANCHES

Use a light wash of Raw Umber to build darks throughout with your medium sponge, applying with circular strokes. Apply Sap Green next in light washes over the needle areas.

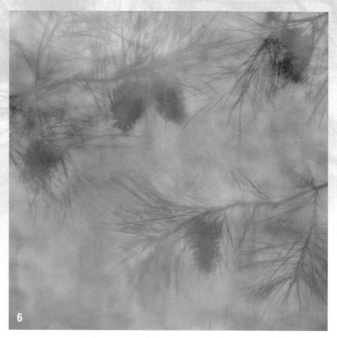

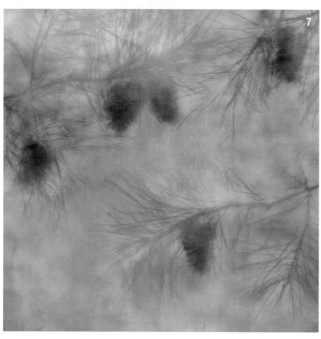

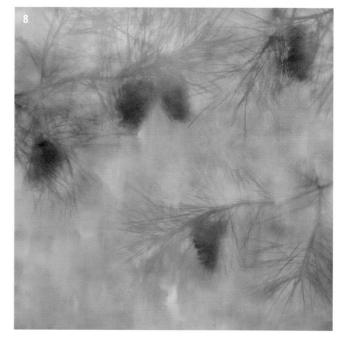

5| ADD COLOR TO THE PINECONE AREAS
Use your medium sponge to apply Burnt Sienna washes over the pinecone areas and within the branches.

6| ADD COLOR TO THE SKY
Use your medium sponge with Light Blue Violet to bring back the bright blues of the sky, crosshatching for texture.

7| DARKEN THE PINECONES
Use Burnt Umber to darken the pinecones with the small sponge, applying a heavy coat then flipping to the clean side to blend in.

8| ADD MORE TEXTURE TO THE SKY
Crosshatch Unbleached Titanium into the sky area and behind the branches using your small sponge.

9| ADD HIGHLIGHTS TO THE SKY AND PINECONES

Go back over the sky with your small sponge and Titanium White, adding brighter crosshatched areas throughout.

Then add Titanium White as snowy details on the pinecones, using the edge of your small sponge to dab downward to make a heavy edge of paint in ruffle shapes. Just a little bit here and there will convey the idea to the viewer.

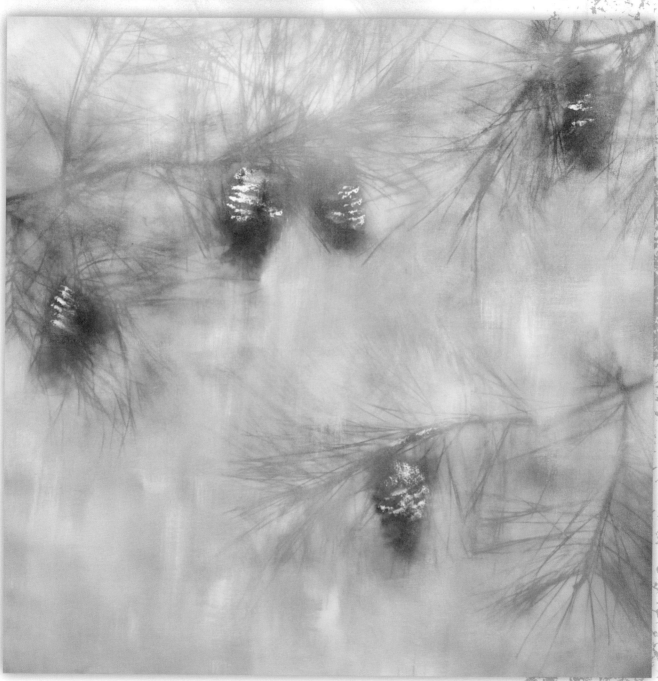

winter haze | acrylic and spray paint on 24" × 24" (61cm × 61cm) gessoed canvas

warm promises

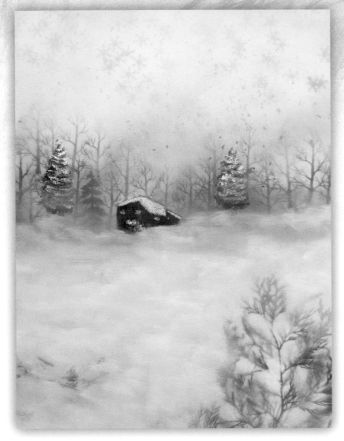

This charming winter scene is made all the more magical by using fun snowflake confetti as falling snow. A blue underpainting will provide just the right base for the big snowy field, with evergreen branches making the scene even more realistic.

materials

FOUND OBJECTS
snowflake confetti
tree and cottage paper cutouts

NATURAL PLANTS
evergreen branch

SURFACE
140-lb. (300gsm), 24" × 18" (61cm × 46cm) gessoed watercolor paper

Burnt Sienna

Burnt Umber

Cadmium Yellow Medium

Hooker's Green Hue
Permanent

Light Blue Permanent

Light Blue Violet

Raw Sienna

Raw Umber

Sap Green

Titanium White

House Highlights
(Burnt Sienna +
Titanium White)

Snow/Sky Wash
(Light Blue Violet
+ Raw Umber)

1| PAINT THE OVERALL BACKGROUND

Mist the paper lightly with clear water and use your large sponge double loaded with Light Blue Violet and Light Blue Permanent to apply the entire background. Let dry.

2| PAINT THE TREE AREAS

Use your medium sponge with Sap Green to add the evergreen area on the right side.

3| COMPLETE THE BASECOAT

Use your medium sponge with Raw Umber to add a base layer for the background trees and the house, and for the twigs in the foreground, blending and fading into the blue background. Let dry.

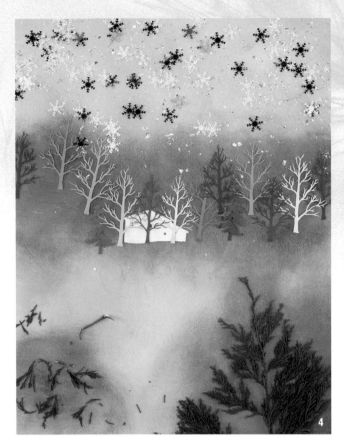

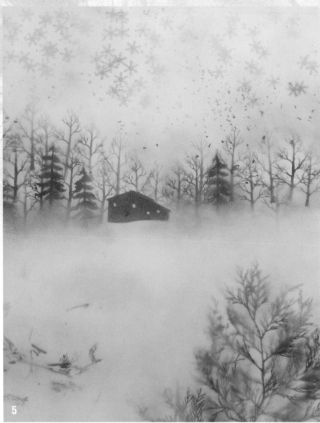

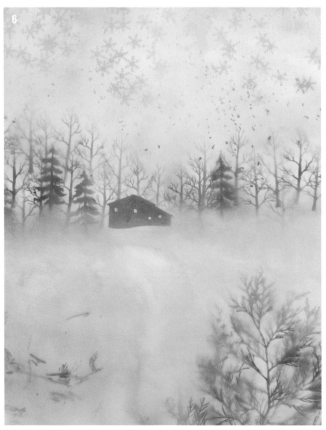

4| COMPOSE THE PAINTING

Place some evergreen branches and broken pieces in the foreground, and tree and cottage cutouts in the background. Sprinkle the snowflake confetti in the sky area, coming down into the trees.

5| SPRAY YOUR DESIGN

Hold down any props that are rising too high from the surface as you spray so you get a good masking of the objects. There are a lot of props here; if you don't have enough and need to reuse some, it's OK to spray, move and spray in a new place.

6| ADD COLOR TO THE SNOW AND SKY

Mix Light Blue Violet with Raw Umber (leaning toward blue), and use your medium sponge to wash this over the sky and snow.

Then add some Light Blue Permanent to the snow area here and there, flipping the sponge to the clean side to blend it in just a bit.

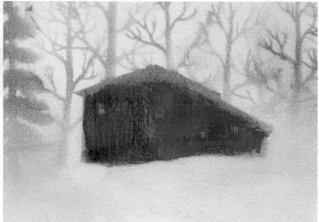

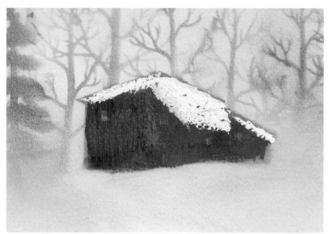

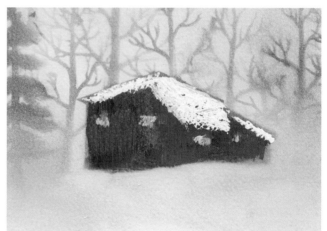

7| PAINT THE COTTAGE

Detail the house dark to light. Start with Burnt Umber to loosely paint the house with your small sponge, then use your small sponge to add a mix of Burnt Sienna and Titanium White to highlight the side of the building in the sun and to give the building dimension. Apply Titanium White with the corner of your small sponge to add a snowy rooftop. Then use the corner of your small sponge with Cadmium Yellow Medium to fill in the windows, finishing the building.

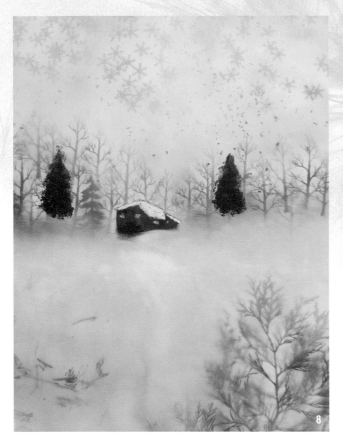

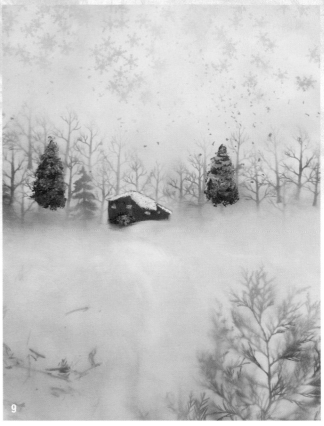

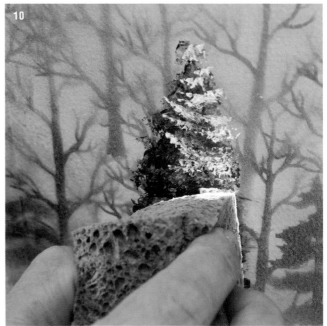

8| PAINT THE BACKGROUND EVERGREENS

Use your small sponge with Hooker's Green to go over the evergreens, and to dab some bushes in front of the house. Then wash a little green here and there in the tree line, blending the color into the painting.

9| GIVE THE EVERGREENS FORM

Add a little Cadmium Yellow Medium and Titanium White to the Hooker's Green to make a bright green and highlight the evergreen trees and bush, using the corner of your small sponge.

10| HIGHLIGHT THE EVERGREENS

Add snowy highlights to the trees and the bush using the corner of your small sponge with Titanium White, dabbing on the color in uneven rows.

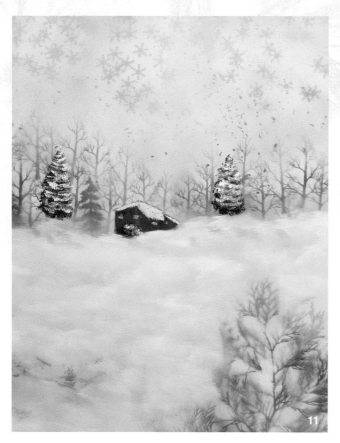

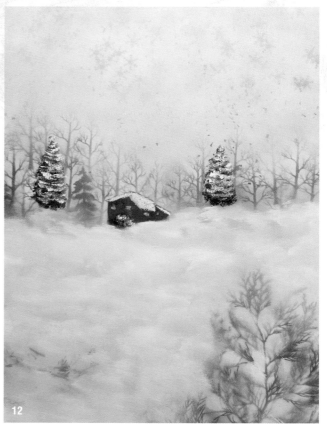

11| ADD SHAPE TO THE SNOWFIELD

Use your small sponge with Titanium White to shape the land, starting at the top under the trees, dabbing in color heavy at the top of each shape then flipping the sponge to blend the color out a bit. Leave gaps between the white to portray dips and raised areas in the snow.

12| PAINT OVER THE SKY

Use a medium sponge with Titanium White to wash over the sky area using circular strokes. Let the land and sky dry.

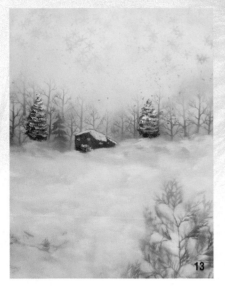

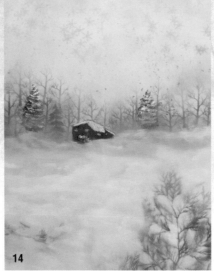

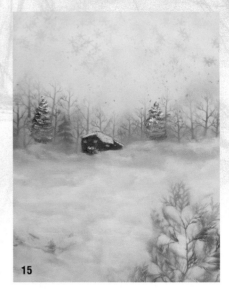

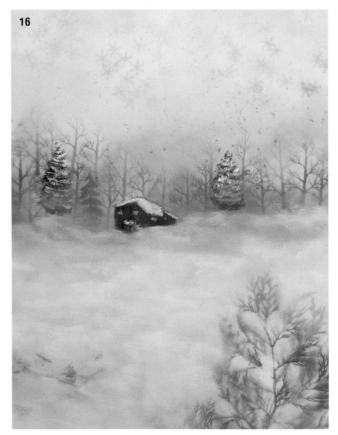

13| ADD COLOR TO THE BACKGROUND TREES

Add a light wash of Raw Umber into the background tree line with your medium sponge, blending the color into the snow and sky.

14| ADD DEPTH TO THE TREE LINE

Use your sponge with Light Blue Violet to shade the bottom of the background trees and a little into the snow, flipping to blend color. It's OK to go over the trees a bit.

15| DEVELOP THE SNOWFIELD

Add more Light Blue Permanent to the snow with your small sponge, applying color mostly in the foreground.

16| ADD A GLOW TO THE SKY

Use your small sponge with Raw Sienna to put a glow in the sky over the cottage, adding some to the roof of the cottage and the snowy field in front of the cottage as a reflection of the sun in the snow.

17| HIGHLIGHT THE GLOW (OPPOSITE PAGE)

Add Cadmium Yellow Medium on top of Raw Sienna to heighten the warm glow.

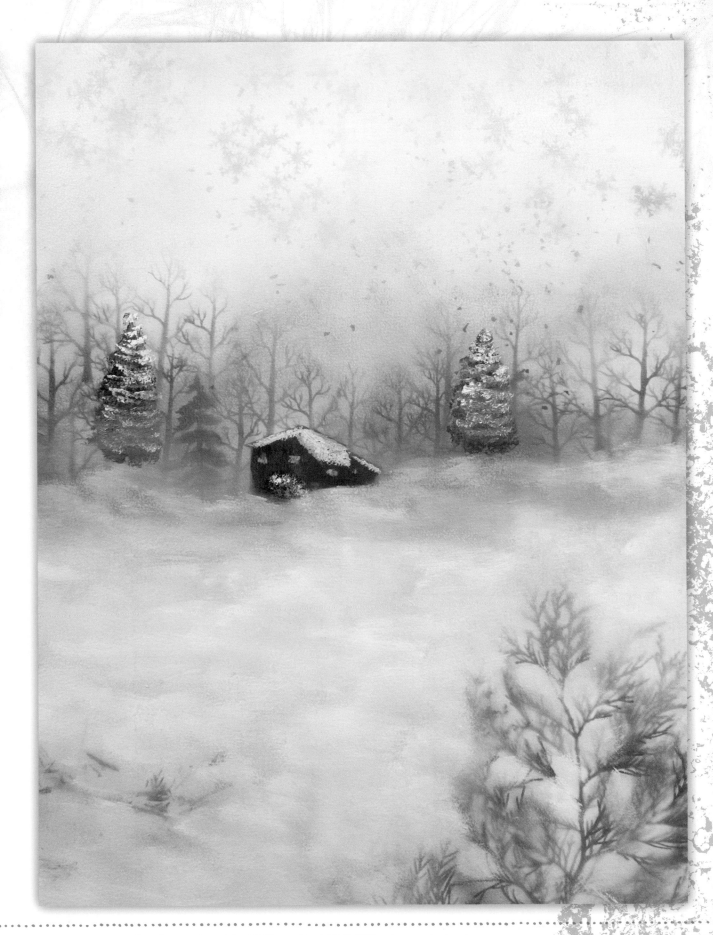

warm promises | acrylic and spray paint on 24" × 18" (61cm × 46cm) 140-lb. (300gsm) gessoed watercolor paper

rain wash

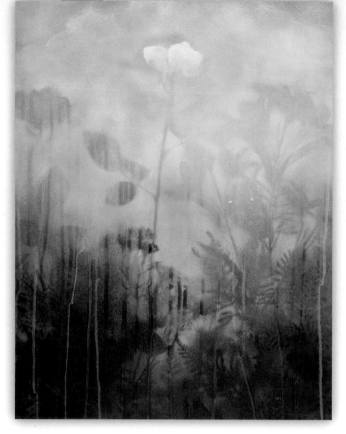

Flowers love a good spring rain. In this demonstration you'll learn how to take advantage of the qualities of acrylic and gesso to create a realistic rain effect that sets this painting apart from a typical garden scene.

materials

SILK AND PLASTIC PLANTS
roses

lacy ferns

small- and medium-sized flowers with foliage

SURFACE
140-lb. (300gsm), 24" × 18" (61cm × 46cm)
gessoed watercolor paper

Bright Aqua Green

Burnt Sienna

Dioxazine Purple

Light Blue Violet

Raw Umber

Sap Green

Titanium White

Unbleached Titanium

*Sky Spots
(Light Blue Violet
+ Raw Umber)*

1| PAINT THE SKY BASECOAT

Mist the paper lightly with clear water and use your large sponge to apply Light Blue Violet to the top half of the painting, fading the color as you move down the paper.

2| PAINT THE FOLIAGE BASECOAT

Use your medium sponge to apply Sap Green over the bottom area, fading as you go up and blending into the sky area. Let this dry.

3| APPLY BASECOATS FOR THE FLOWERS

Use your small sponge to apply Dioxazine Purple to the middle area, Bright Aqua Green to the upper right of the painting, and Unbleached Titanium in the center rose area. Let this dry.

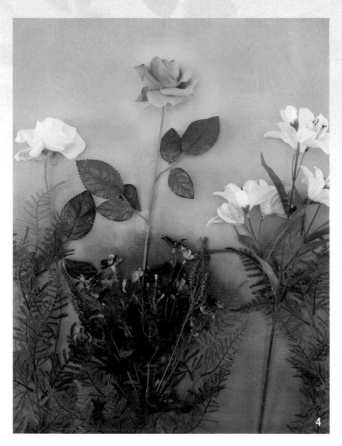

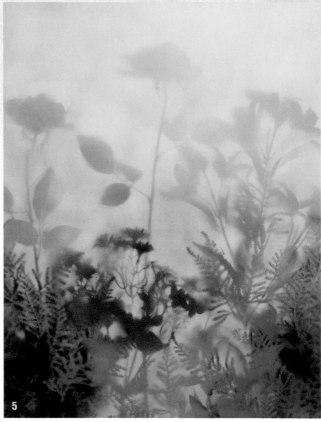

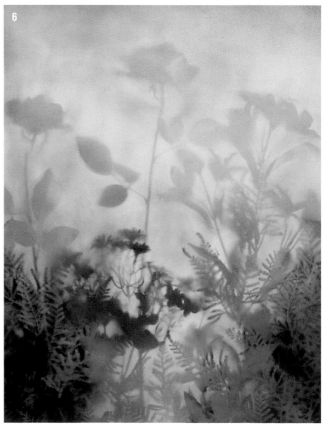

4| COMPOSE THE PAINTING

Place the roses, small- and medium-sized flowers on the painting, making sure to ruffle the petals on the roses so they have a varied and interesting shape. Place the ferns as the lower foliage area.

5| SPRAY YOUR DESIGN

Hold down any props that are rising too high from the surface as you spray so you get a good masking of the objects.

6| ADD COLOR TO THE SKY AND FOLIAGE

Use your medium sponge to wash Raw Umber over the sky area, applying color heavy at the top and fading down. Use circular strokes and go over the flowers.

Wash in Sap Green on either side of the lower foliage area using your medium sponge, flipping to blend and fade the color into the sky area.

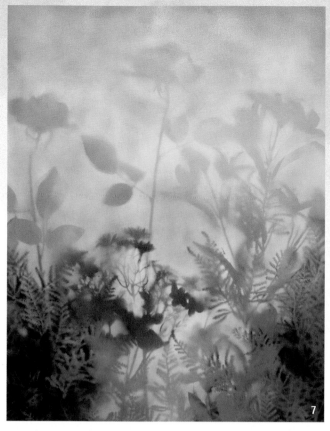

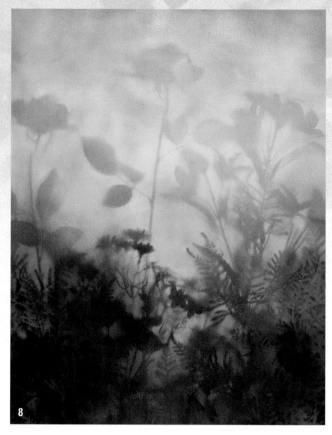

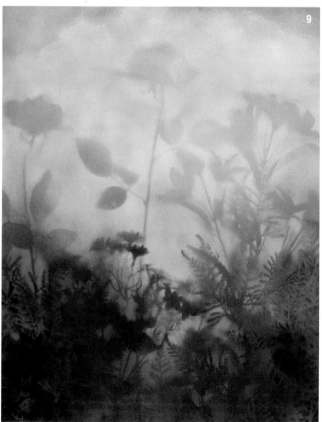

7| ADD SOME BLUE TO THE SKY

Mix Light Blue Violet and Raw Umber for a warm blue and spot the sky here and there using your small sponge, washing over the umber in some areas, but allowing it to show through in other areas.

8| WARM UP THE FOLIAGE

Use your medium sponge with Burnt Sienna to deepen the bottom center area of the foliage, flipping the sponge to blend and fade the color up into the sky and out into the foliage.

9| DEVELOP THE SKY

Use your small sponge with Unbleached Titanium to put some soft clouds in the sky areas, dabbing in color and fading it out at the bottom of each cloud shape.

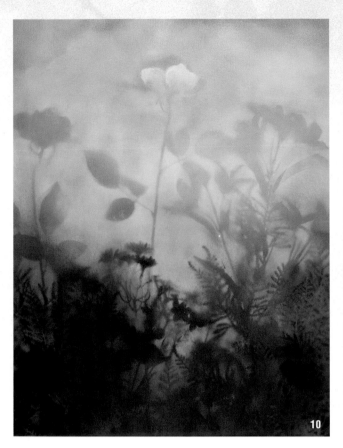

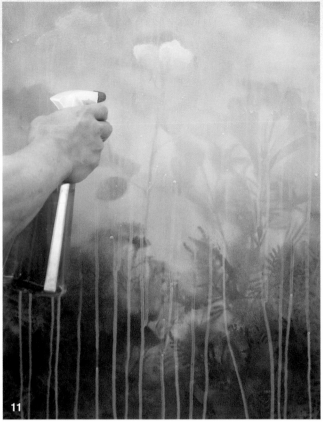

10| HIGHLIGHT THE CENTER ROSE

Use your small sponge with Titanium White to detail the center rose, adding color by pinching the sponge to create the harder edges at the top and using the belly of the sponge to fill in the larger shape of the petal.

11| CREATE THE RAIN

Use your large sponge with Unbleached Titanium to put a light wash over the entire surface, working very quickly to apply and then flipping to blend.

While this is still wet, mist and spray clear water down the painting, letting the Unbleached Titanium run and drip down the surface.

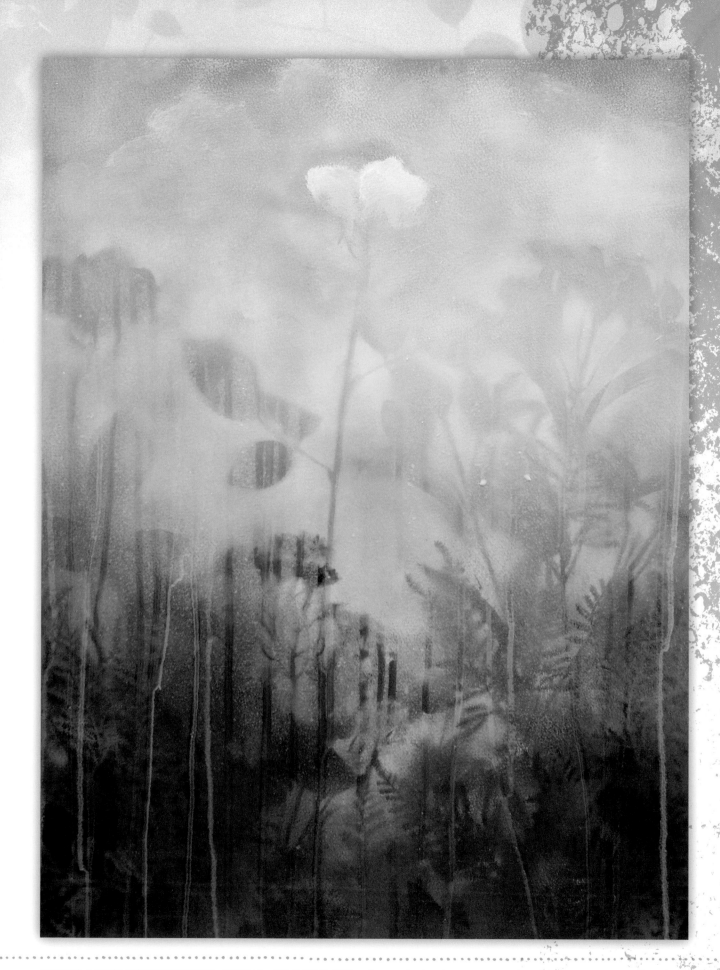

rain wash | acrylic and spray paint on 24" × 18" (61cm × 46cm) 140-lb. (300gsm) gessoed watercolor paper

spring
wild pastels

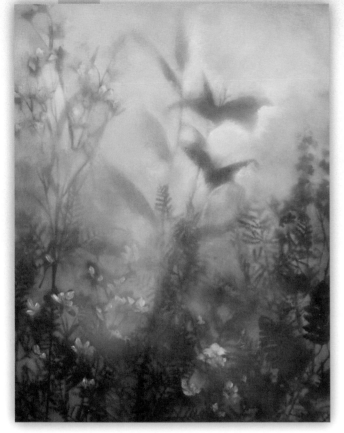

A vibrant basecoat proclaims that spring has sprung in this glorious garden scene. In this demonstration you'll create a rainbow of fresh, new flowers backlit with the warm, glowing sun!

materials

SILK AND PLASTIC PLANTS
lilies
lacy ferns
small- and medium-sized flowers with foliage

SURFACE
24" × 18" (61cm × 46cm) gessoed canvas

Brilliant Purple

Burnt Sienna

Cadmium Yellow Medium

Cobalt Blue

Medium Magenta

Raw Sienna

Raw Umber

Sap Green

Titanium White

Unbleached Titanium

*Dark Foliage
(Sap Green + Raw Umber)*

1| PAINT THE LILY BASECOAT

Wet the canvas and apply Cobalt Blue in the upper right area using your medium sponge with a circular motion, flipping the sponge to fade the color at the edges.

2| PAINT THE FLOWER AND GLOW BASECOATS

Apply Medium Magenta in the upper left area with your medium sponge, flipping the sponge to fade the edges and blend with the blue. Apply Cadmium Yellow Medium as the glow in the middle, flipping the sponge to fade and blend into the other colors.

3| PAINT THE FOLIAGE BASECOAT

Apply Sap Green mixed with Raw Umber to the rest of the lower area using your medium sponge and a circular motion, flipping the sponge to fade out the edges and blend into other areas. Let this dry.

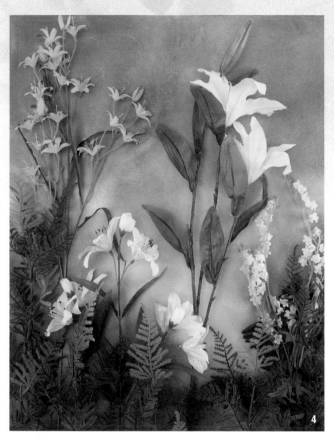

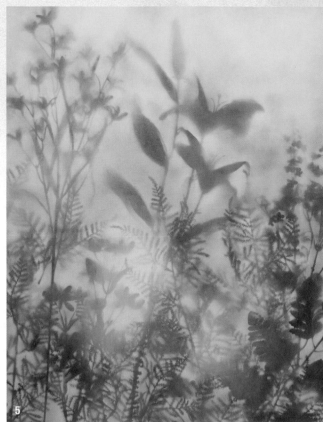

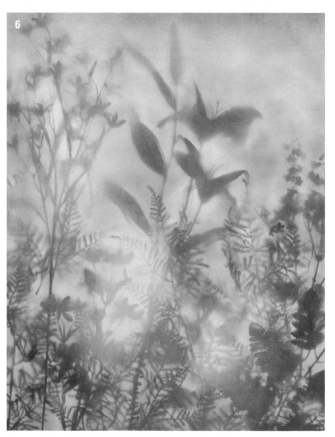

4| COMPOSE THE PAINTING

Place the lilies, small- and medium-sized flowers on the painting, placing the lilies just above the central glow. Place the ferns as the lower foliage area.

5| SPRAY YOUR DESIGN

Hold down any props that are rising too high from the surface as you spray so you get a good masking of the objects.

6| ADD COLOR TO THE SKY

Apply Raw Sienna with your medium sponge, starting heavy at the top and fading down. Apply a little in the bottom center as well. Use a clean sponge to pick up some color between the flowers to bring back some of the light sky.

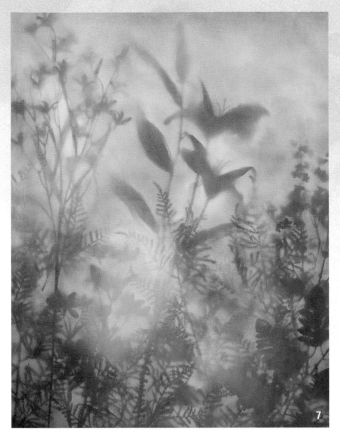

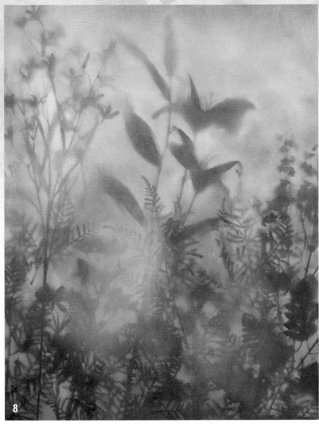

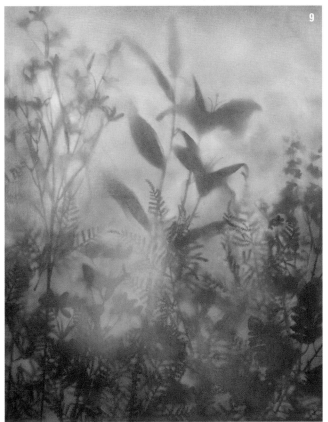

7| ADD COLOR TO THE FOLIAGE AREA

Deepen the foliage on each side with Sap Green and your medium sponge, starting heavy at the bottom then fading up.

8| DEEPEN THE CENTRAL GLOW

Add to the central glow with a wash of Burnt Sienna using your medium sponge. Start heavy at the bottom and fade up. Apply the color in a circular motion.

9| ADD DEPTH TO THE FOLIAGE

Dry the green areas. Then go over the green with Raw Umber, using your medium sponge and flipping to blend the color in as a light wash.

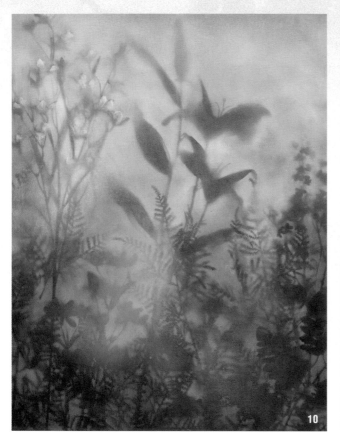

10| PAINT THE PINK FLOWERS

Mix Medium Magenta and Titanium White (not fully mixed), and dab in the petals with the corner of your small, pinched sponge, using the back of the sponge to blend out the color a little bit.

11| PAINT THE LOWER-LEFT FLOWERS

Apply Titanium White with your small sponge to detail small flowers using the corner of the sponge. Use the back of the sponge to blend out some of the petals.

12| PAINT THE YELLOW FLOWERS

Use Cadmium Yellow Medium mixed with a little Titanium White (don't fully mix the colors) to paint the lower central small flowers. Just dab in petals with the corner of your small sponge, then use the back of the sponge to soften and blend out some areas.

13| ADD MORE GENERAL COLOR TO THE LOWER FLOWER AREA

Use Brilliant Purple and your small sponge to apply color within the lower flower areas, flipping and blending the color into the painting.

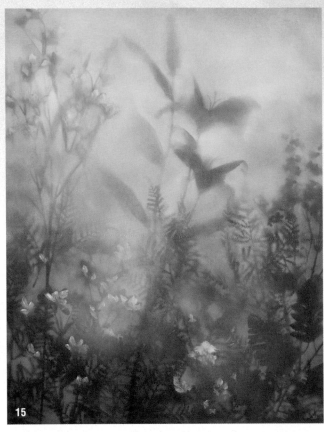

14| ENHANCE THE BACKLIGHTING EFFECT

Apply Unbleached Titanium with your small sponge between the flowers to lighten some areas and help soften colors and edges. The more white you put over an area of color, the farther back into the painting you will push it. Flip and blend the white into the painting.

15| ENHANCE THE SUN'S GLOW

Strengthen the sun's glow with an additional layer of Burnt Sienna. Use your small sponge and work between the flowers, fading the color into the sky and foliage.

16| PUSH THE BACKLIGHTING STILL FURTHER

Apply Titanium White somewhat heavy around the edges of the petals on the central lilies using the corner of your small sponge, flipping the sponge to soften and blend out the white.

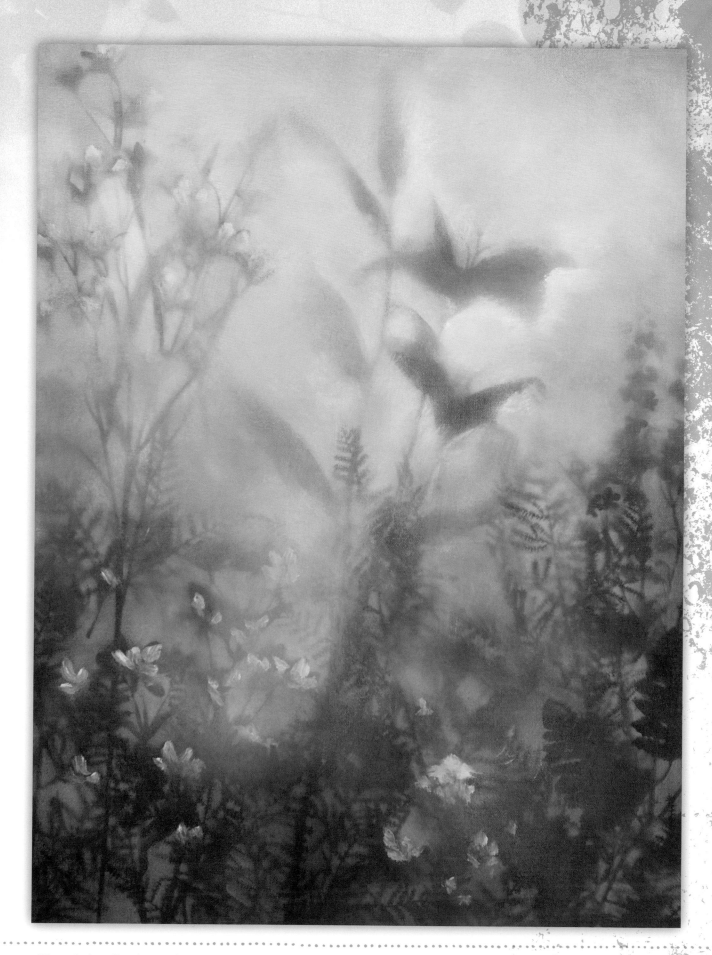

wild pastels | acrylic and spray paint on 24" × 18" (61cm × 46cm) gessoed canvas

illuminating clarity

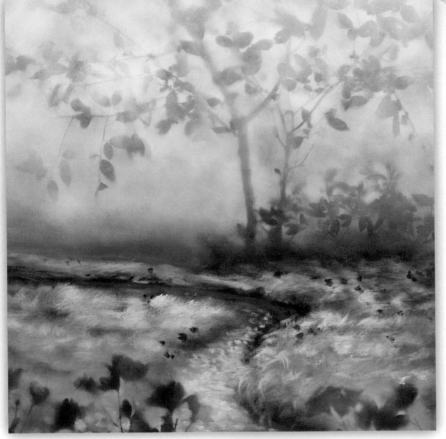

Follow the bubbling brook into this secret spring hideaway. A detailed basecoat provides a strong compositional foundation for this painting, helping to lead the viewer's eye through the scene.

materials

NATURAL PLANTS
ficus leaves and branches
smaller twigs with foliage

SILK PLANTS
medium-sized flowers and foliage

SURFACE
24" × 24" (61cm × 61cm)
gessoed canvas

Brilliant Purple

Brilliant Yellow Green

Burnt Umber

Cadmium Orange

Cadmium Red Light

Cadmium Red Medium

Light Blue Permanent

Raw Sienna

Raw Umber

Sap Green

Titanium White

Ultramarine Blue

*Dark Grasses
(Sap Green + Raw Umber)*

*Dark Landmass
(Sap Green + Burnt Umber)*

*Sky Wash
(Light Blue Permanent
+ Raw Umber)*

*Stream
(Ultramarine Blue
+ Raw Umber)*

112

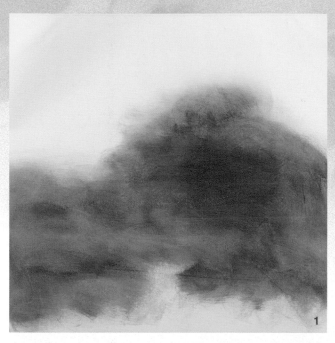

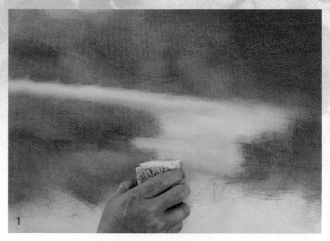

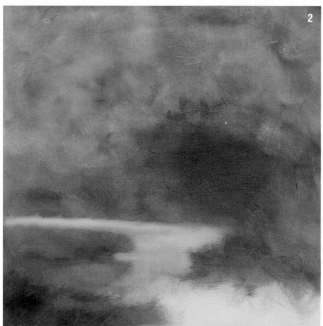

1| PAINT A BASECOAT FOR THE LAND AND TREE AREA

Wet the canvas and apply Raw Umber with a medium sponge to establish the landmass and tree area, flipping to blend and fade the outer edges.

Use the edge of a clean small sponge to pick up some of the color to create the stream.

2| PAINT A BASECOAT FOR THE UPPER AND LOWER FOLIAGE AREAS

Double load your medium sponge with Brilliant Yellow Green and Sap Green and paint the tree foliage at the top.

Mix Sap Green and Raw Umber and paint the grassy area at the bottom.

3| PAINT A BASECOAT FOR THE FLOWERS

Double load one side of your small sponge with Cadmium Red Medium and Cadmium Red Light, and load the other side of the sponge with Cadmium Orange. Use these colors to mottle in the flower areas and then blend them together a bit. Let this dry.

4| COMPOSE THE PAINTING

Place the ficus branches and leaves at the top as a large tree and place a couple of the smaller twigs underneath to portray small bushes. Put the silk flowers at the bottom with the blossoms in the red areas.

5| SPRAY YOUR DESIGN

Hold down any props that are rising too high from the surface as you spray so you get a good masking of the objects. Leave the area around the bend in the stream free from spray.

6| BLOCK IN THE STREAM

Mix a dark blue with Ultramarine Blue and Raw Umber and use your small sponge to apply it as an underlayer for the stream. Use horizontal strokes and flip the sponge to the clean side to blend and fade as you move into the foreground.

7| BLOCK IN THE LAND

Mix a dark green with Sap Green and Burnt Umber and use your medium sponge to block in the land-mass, laying in color heavier at the top and flipping the sponge to fade and blend as you move down to the foreground. Blend color up into the background foliage using horizontal and circular strokes.

Go back in with the same mix and use the corner of your sponge to darken the area next to the stream bank.

8| ADD THE BANK OF THE STREAM

Use the edge and corner of your small sponge to apply Raw Sienna under the dark green around the stream bank as indications of raw earth, flipping the sponge to blend or wipe away color as needed.

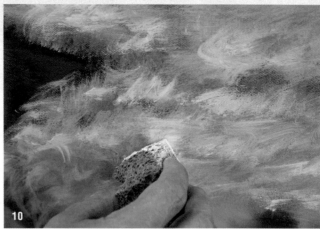

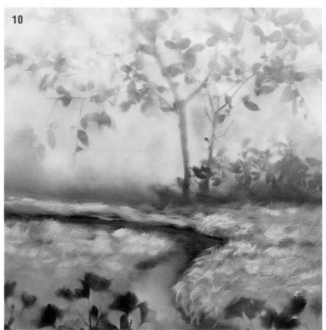

9| ADD GRASSES TO THE LAND

Use your medium sponge with Brilliant Yellow Green to put in grass along the distant land with horizontal strokes using the edge of the sponge. Then come in with the same color and use vertical strokes on the larger land-masses, with some areas blotted for a variety of grassy texture, curling long grasses down over the stream's bank to show the sloping bank by the water. The Brilliant Yellow Green is almost transparent and doesn't lay in opaquely so you may have to continue to build the layers until you get the grass as bright as you want it.

10| HIGHLIGHT THE GRASSES

Add Titanium White to the Brilliant Yellow Green and add highlights in the grass with the edge of your small sponge, blotting and dabbing in areas of texture as well.

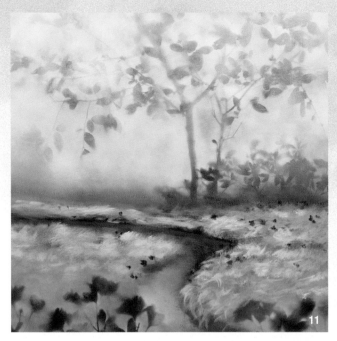

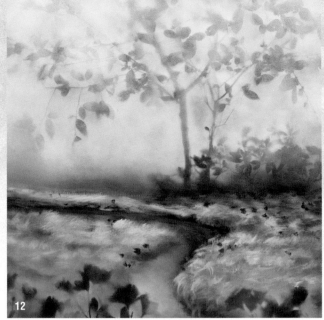

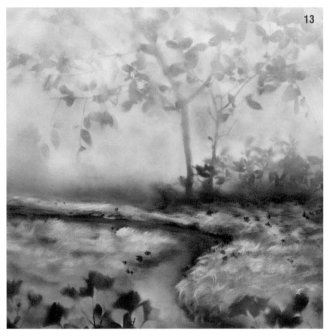

11| ADD FLOWERS IN THE GRASS

Scatter some small dabs of Cadmium Red Medium over the grassy area as flowers using the corner of your small sponge.

Go over this with Cadmium Orange to highlight some of the red flowers in the grass and to add more flowers throughout the grass, again using the corner of your small sponge.

12| SHADOW THE WATER AND GRASS

Mix a dark green from Sap Green and Raw Umber and deepen some areas of the grass with your small sponge. Dab in color here and there, then flip the sponge to blend as you go. Add dark green into the water at the bend in the stream to shadow.

13| ADD COLOR TO THE SKY

Mix a medium blue with Raw Umber and Light Blue Permanent and use your medium sponge to wash this over the sky.

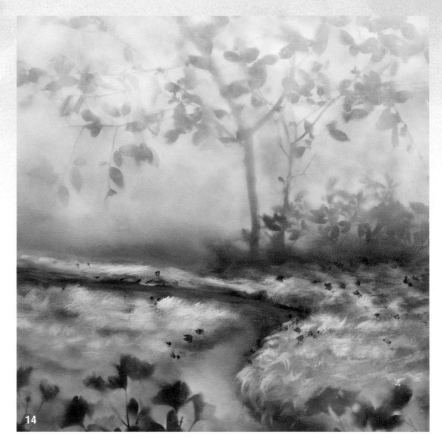

14| ADD MORE COLOR TO THE SKY

Use your medium sponge to wash Brilliant Purple very lightly over the lower part of the sky.

15| DEEPEN THE BACKGROUND

Wash Raw Umber in the area just above the land and into the foliage.

16| ADD FINAL HIGHLIGHTS TO FINISH THE WATER (OPPOSITE PAGE)

Use the corner of your small sponge with Titanium White to add the reflections and ripples in the water. Use the corner of your sponge and dab on a variety of small shapes.

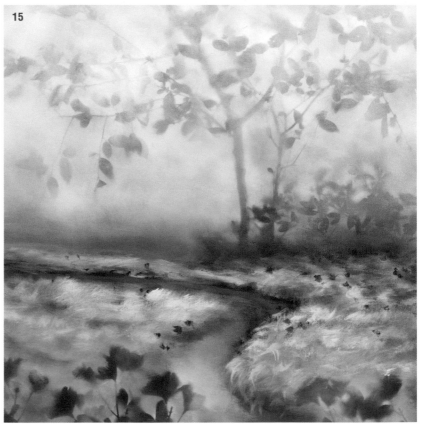

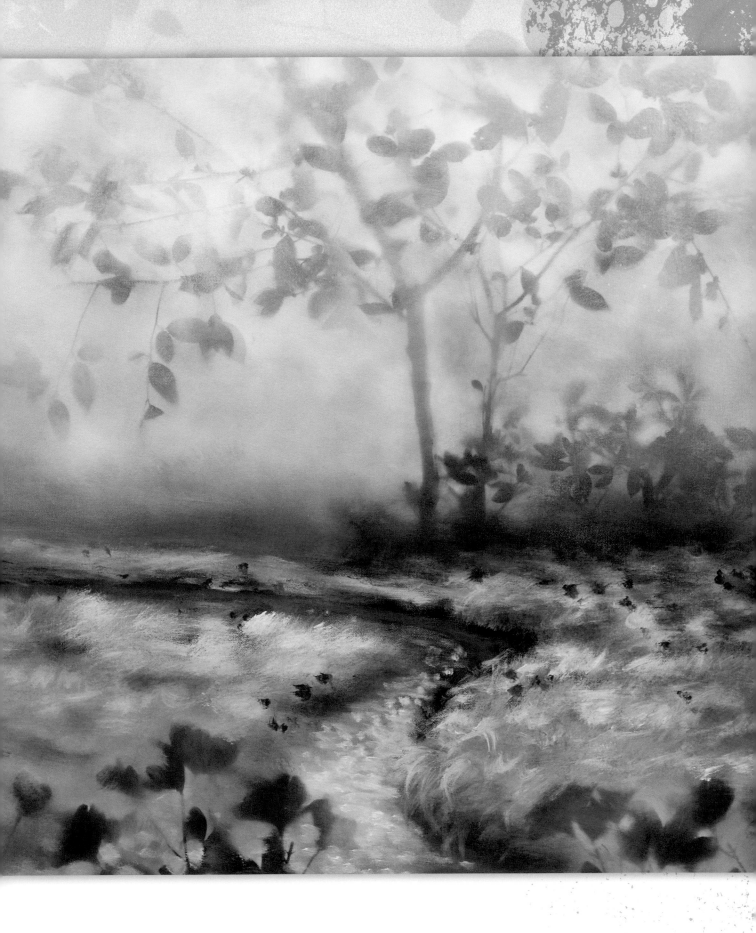

illuminating clarity | acrylic and spray paint on 24" × 24" (61cm × 61cm) gessoed canvas

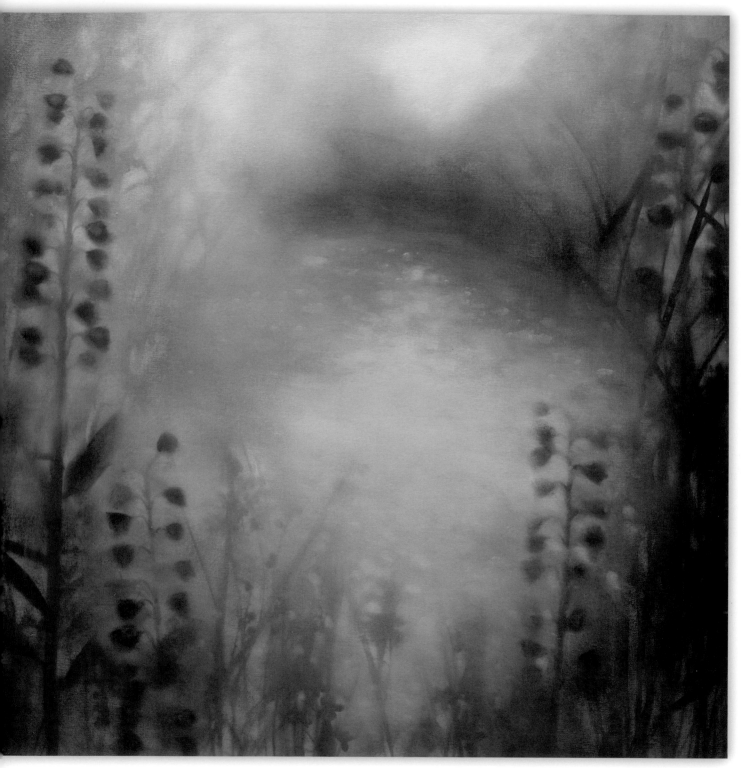

river edge (above)
acrylic and spray paint on 24" × 24" (61cm × 61cm) gessoed canvas

summer whites (right)
acrylic and spray paint on 24" × 18" (61cm × 46cm) gessoed canvas

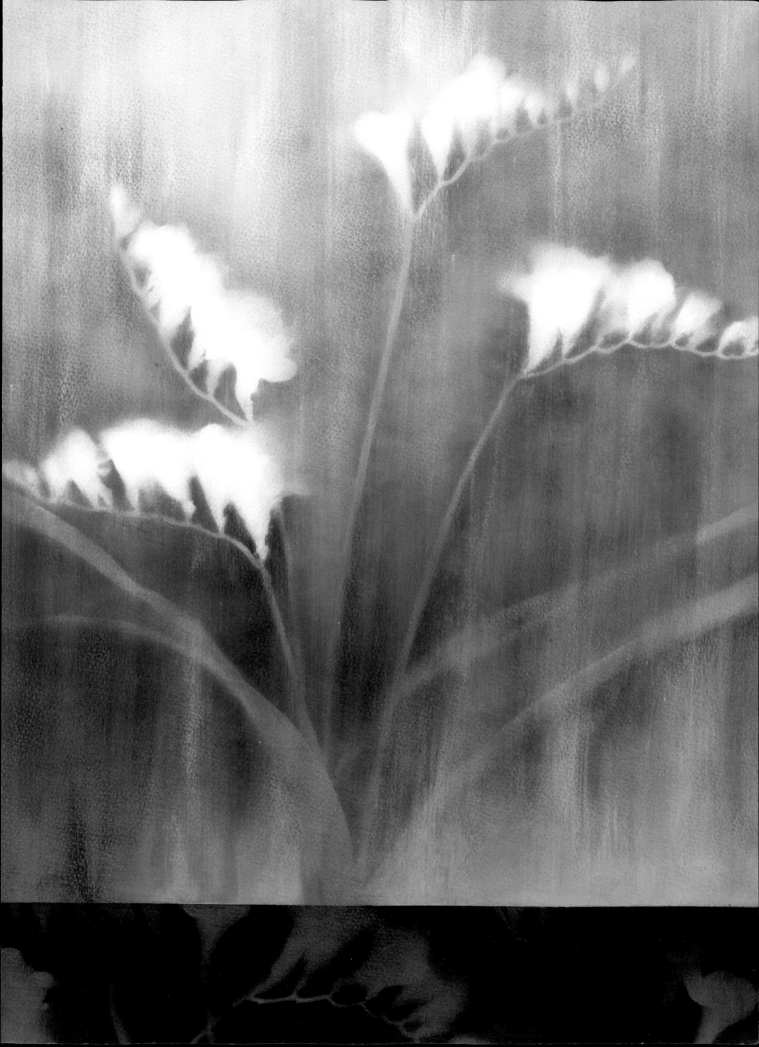

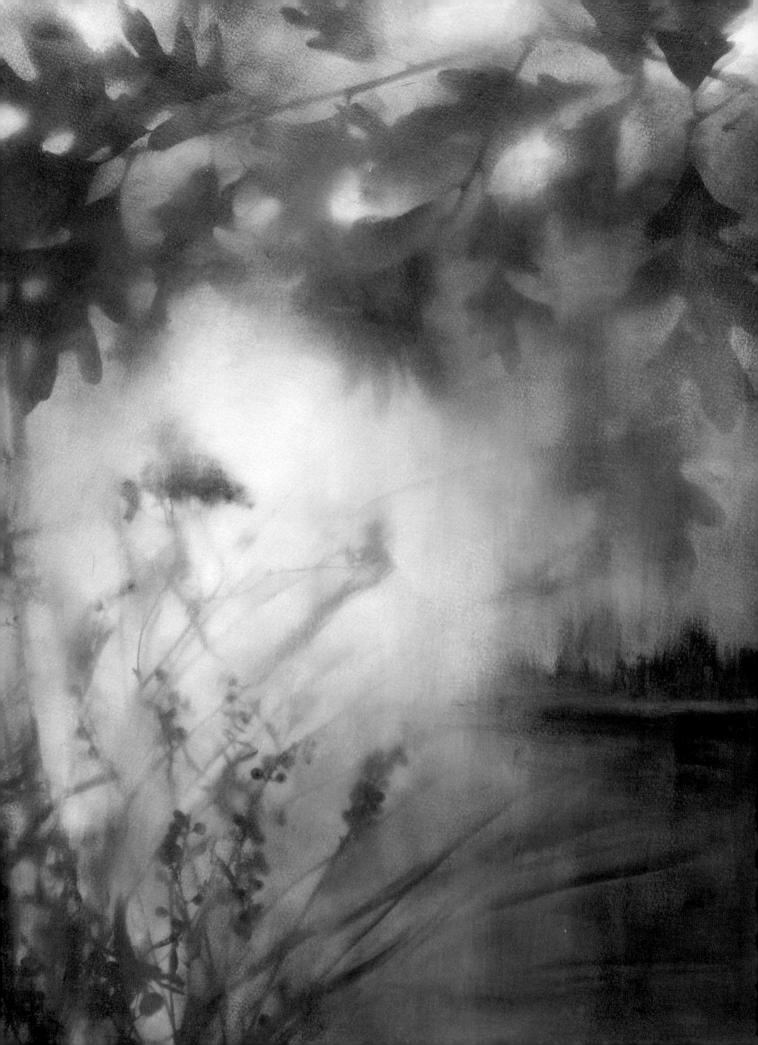

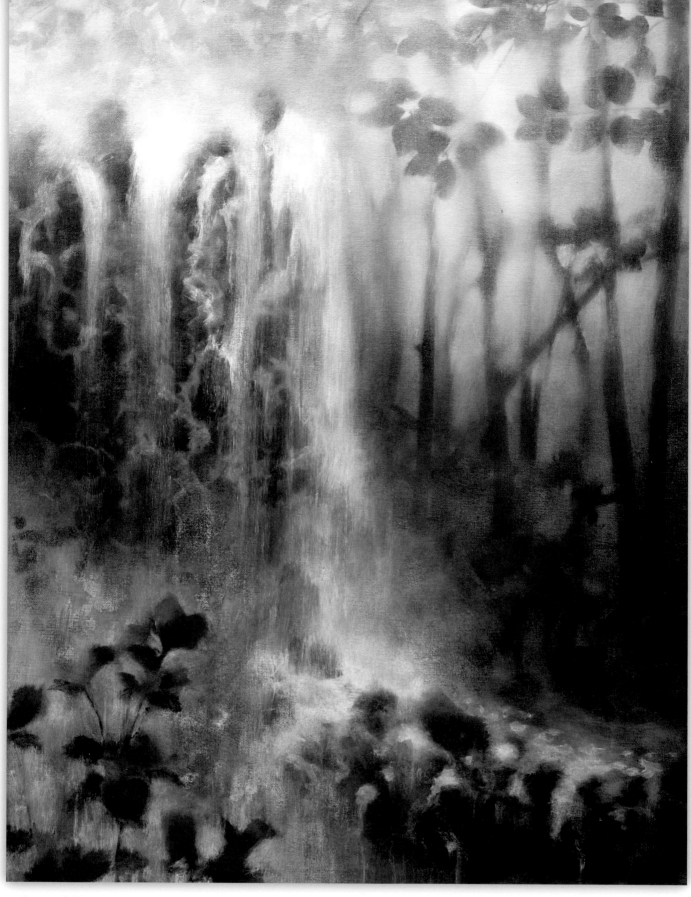

far away (left)
acrylic and spray paint on 24" × 18" (61cm × 46cm) gessoed canvas

romantic interests (above)
acrylic and spray paint on 24" × 18" (61cm × 46cm) gessoed canvas

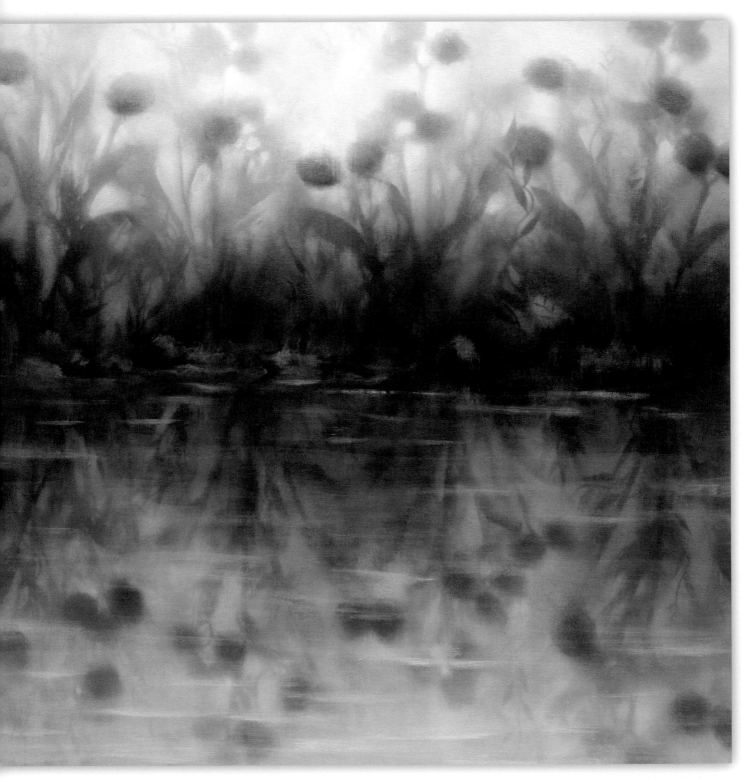

thistling in the wind
acrylic and spray paint on 24" × 24" (61cm × 61cm) gessoed canvas

lampshade, vase and decorative box
The spray paint and sponge painting techniques from
this book also work on three-dimensional surfaces.

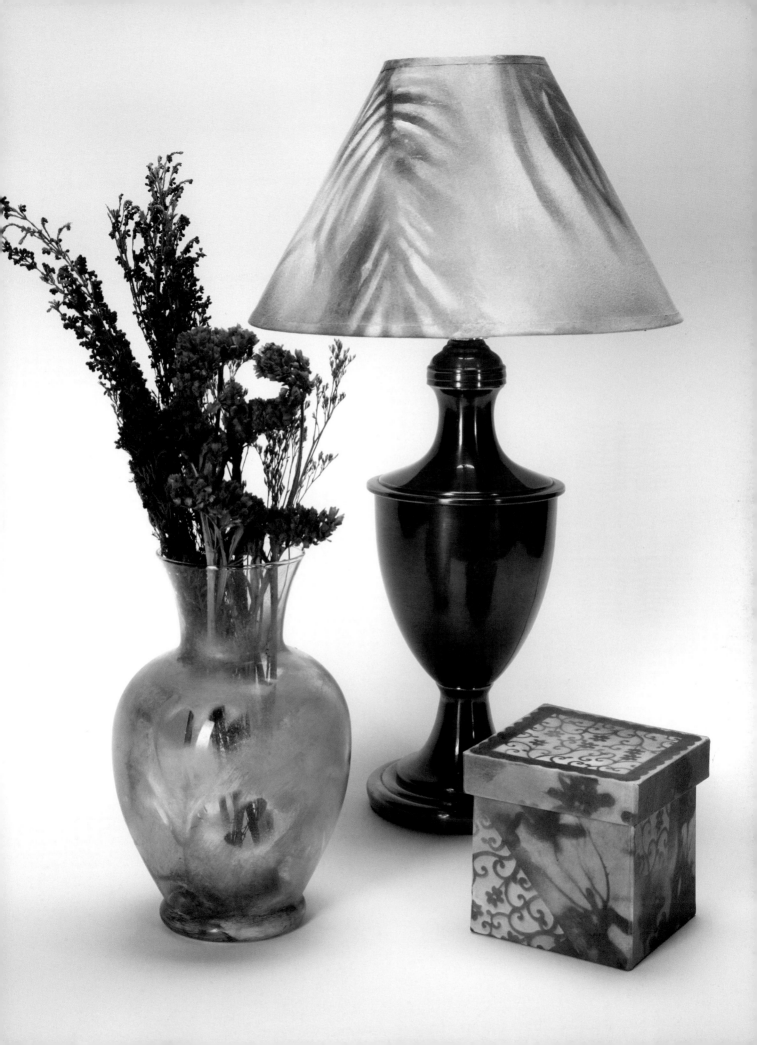

index

resources

Liquitex Artist Acrylic

Liquitex developed their first water-based acrylic products in 1955 and have been developing and producing new products for artists ever since.

Visit **www.liquitex.com** for product, technique or general information or call (888) 4-ACRYLIC (227942).

Utrecht Art Supplies

Utrecht has been making art supplies since 1949, developing their first acrylic products in 1957 and continuing to develop and produce new products for artists ever since.

Visit **www.utrechtart.com** for a full list of products and general information or call (800)-233-9132.

Golden Artist Colors

Golden started making artist materials in the 1930s, developing and producing their first acrylic products in 1949 and continuing to develop and produce new products for artists ever since.

Visit **www.goldenpaints.com** for a full list of products and general information or call (800) 959-6543.

Ideas. Instruction. Inspiration.

These and other fine North Light products are available at your favorite art and craft retailer, bookstore or online supplier. Visit our websites at **www.artistsnetwork.com** and **www.artistsnetwork.tv**.

ISBN 13: 978-1-60061-997-7
Z6463 | DVD running time: 61 minutes

ISBN-13: 978-1-58180-962-6
Z0686 | paperback • 128 pages

ISBN 13: 978-1-4403-0235-0
Z6467 | DVD running time: 60 minutes

Visit **www.artistsnetwork.com** and get Jen's North Light Picks!

Get free step-by-step demonstrations along with reviews of the latest books, videos and downloads from Jennifer Lepore, Senior Editor at North Light Books and Online Education Manager.